When the Bough Breaks:

Pregnancy and the Legacy of Addiction

Kira Corser
Photography and Narratives

Frances Payne Adler
Poetry and Narratives

Foreword by
Jennifer Howse, Ph.D.

NewSage

PRESS

Dedicaton

*To the day when women and children
are safe in this world.*

**Library of Congress
Cataloging-in-Publication Data**

Corser, Kira, 1951-
 When the bough breaks: pregnancy and
the legacy of addiction / Kira Corser,
photography and narratives ; Frances Payne
Adler, poetry and narratives ; foreword by
Jennifer Howse.
 p. cm.
 "Resources" : p.
 ISBN 0-939165-20-1 : $39.95 —
 ISBN 0-939165-19-8 (pbk.) : $22.95
 1. Substance abuse in pregnancy—
Miscellanea. 2. Children of prenatal sub-
stance abuse—Miscellanea. 3. Abused
women—Substance use—Miscellanea.
4. Substance abuse in pregnancy—Pictorial
works. 5. Children of prenatal substance
abuse—Pictorial works. 6. Abused
women—Substance use—Pictorial works.
I. Adler, Frances Payne, 1942- . II. Title.
RG580. S75C67 1993
618.3'268—dc20 93-5611
 CIP

Acknowledgments

We would like to thank the women in recovery who so honestly and
courageously shared their stories.

We would also like to thank *Las Patronas* and the March of Dimes
Birth Defects Foundation for their generous support, and our publish-
ers, Maureen Michelson and Rhonda Hughes, for their belief in
our work.

Thank you also to the California Women's Commission on Alcohol
and Drug Dependencies; Lisa Firth and the Regional Perinatal
System; University of California San Diego Medical Center; Dr.
Suzanne Dixon and Pat Franklin; and the McAlister Institute for
Treatment and Education.

Special appreciation for their love and time to this project is ex-
tended to our friends and family: Keith Vandevere, Fred Moramarco,
Mariquita Kraft, Katrina Corser, Robert Corser, Allison Adler,
Michael Adler, Sandra Keith, Laura LaRose, Maureen Reardon,
Brick Hatfield, and Ron Coviello.

Grateful acknowledgment is made to Dr. Lenore Walker, director,
Domestic Violence Institute, Denver, Colorado, for her study,
"Abused Mothers, Infants, and Substance Abuse: Psychological
Consequences of Failure to Protect"; and to Dr. Christine Downing,
professor, religious studies, San Diego State University, for the use of
the quote from her book, *The Goddess: Mythological Images of
the Feminine*.

CONTENTS

POEMS

Anyone who has heard the cry of an infant born addicted is not likely to forget it—an anguished and unrelenting cry. It is a cry that can be heard all too clearly and all too often in hospital neonatal intensive-care units across the nation.

With that baby's cry is another—the silent cry of the mother addicted to drugs or alcohol. Her cry, too, is anguished and unrelenting. It speaks of deep, hidden pain masked by her addiction. We now know that more than two-thirds of drug-abusing mothers come from backgrounds of physical and sexual abuse. The pain and powerlessness these women carry from their own abused childhoods have left them easy prey to the disease of addiction.

The cries of addicted women and their babies have gone unheeded for far too long. Politicians in the halls of government are distracted with "more important matters"; hospital staff are overwhelmed facing the growing epidemic of drug addiction with too few resources; beleaguered outreach workers at many drug treatment centers must refuse help to addicted pregnant women because of limited funds; millions of Americans look away out of fear and misunderstanding, hoping to insulate themselves from the problem. And, all the while, the cries persist. They will not go away.

Kira Corser and Frances Payne Adler have heard these cries, and they have raised their voices, creating a stunning book and accompanying exhibition, *When the*

Bough Breaks: Pregnancy and the Legacy of Addiction. The book and exhibition give faces and voices to these cries. Here is evidence that cannot be ignored. One cannot help but be affected—not only by the plight of these women and babies, but also by the hope for their recovery when people hear their cries and step forward to help. With as many as 11 percent of the babies in the United States born to women who used drugs during pregnancy, it is imperative that we hear the stories behind the statistics. Only with understanding can we solve the problem.

Our mission at the March of Dimes Birth Defects Foundation is to improve the health of babies. Helping addicted pregnant women and mothers is very much a part of this work. I thank Fran and Kira for using their art so brilliantly to raise the world's awareness of the multigenerational cycle of abuse that has become the legacy of addiction. The March of Dimes raises its voice with the authors' to create greater understanding about this difficult problem. There is truth and hope in these pages that invite each of us to hear the cries and help break the silence.

—Dr. Jennifer L. Howse
President
March of Dimes Birth Defects Foundation

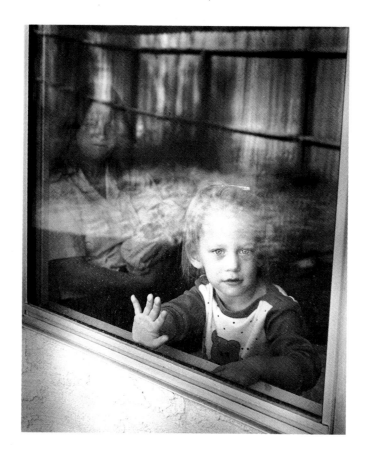

Crack babies. Fetal alcohol syndrome. Pregnant women using drugs. "What is going on here?" we first asked ourselves back in 1988. Almost daily, in newspapers and magazines, we began seeing articles about "drug babies" and addicted mothers, some of them imprisoned for abusing their unborn children. The problem crossed all economic and ethnic backgrounds. We, like most people, were concerned and confused.

In most of the public discussion there was outrage and a desire to label the women as "bad mothers," to blame them as the root of the problem and to put them in jail. The focus was on what needed to be done to punish the women, not to help them. There was great concern for the babies, as there should be, but rarely was there any examination of why the mothers were using drugs and alcohol. "What about the mothers?" we asked. "What about the women who were addicted to drugs and alcohol?" It seemed

all too easy to blame them, to imply that they were "terrible" women. "What were the mothers' stories?" we asked ourselves. We wanted to know why their stories were ignored by the media. These women were our sisters, and their lives were invisible. Each woman's life was being erased by the perception that she was someone's mother, and not a person herself.

Fueled by what we perceived to be unfair, we decided to respond as we had in the past. We would create an exhibition and book of narratives, poetry, and photographs that would document the lives of both the babies and the women.

For the past ten years, we've used our art to effect change by educating both through the heart and the mind. In 1984, when Edwin Meese, our then-attorney general, said, "There is no hunger in America," we responded with our first exhibition, *Home Street Home*, about homelessness. In 1987, with *Struggle to*

Be Borne, we reacted to the thousands of pregnant women denied prenatal care. As we did with these two previous exhibitions and books, we would transport the stories of people not being heard or seen—this time, in the form of *When the Bough Breaks: Pregnancy and the Legacy of Addiction*—to places where they would be heard and seen: to public places, schools, universities, state capitols, and to the nation's Capitol, in Washington, D.C.

And so we began the research, a journey that has taken five years to come to fruition in a book. We talked with the women, the mothers. We talked with women who were in recovery and those who were graduates of treatment programs. Women who had struggled to stop using, and couldn't do it alone. Women whose babies had been taken away. Women who went voluntarily for help, and were refused treatment because they were pregnant, or because recovery programs "didn't take MediCal." We heard stories of survival: women who have changed and are changing their lives, and their children's lives. We also talked to the fathers when we could, as well as to teachers, foster parents, nurses, counselors, social workers, and doctors.

The women's stories haunted us, drained and inspired us, spilled into our dreams. We talked to each other of little else. We learned that every tenth baby born in the United States is being exposed to illegal drugs before birth. And that alcohol use during pregnancy is rampant and the leading cause of preventable mental retardation. We also began to piece together an unspoken story behind the story of addicted pregnant women. Over and over, women in recovery talked about how they had been abused as children, many of them sexually abused. At first we were surprised by the frequency of abuse, and then it became obvious: women who had grown up in alcohol- or drug-abusing families, and who had experienced child abuse, were dealing with their pain as they had been taught to deal with it.

During those months of interviewing, we saw the pattern of abuse emerge—a legacy that was confirmed a year later by Dr. Lenore Walker, director of the Domestic Violence Institute in Denver, Colorado. Her research corroborated our independent findings.

According to Walker's research, "Between 60 to 80 percent of substance-abusing mothers have been sexually or physically abused at some time in their lives." Walker now believes that at least one in three women in the United States has been sexually abused at some time in her life. And one in every five men has been abused. In addition, many of them find partners who perpetuate the abuse. Millions are drugging themselves to forget their pain, their powerlessness. As one woman named Tessa said, "People don't understand when I try to be honest and tell them, Yeah, I was an abuser, but yet I was abused. They don't understand that."

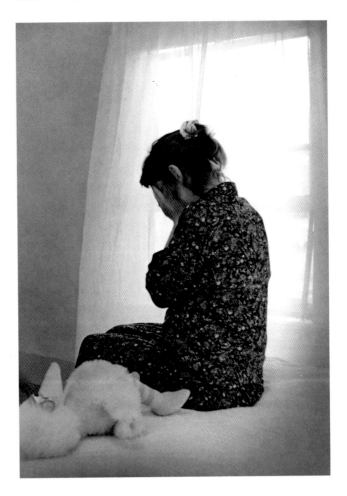

It took great courage for Tessa to speak out about being abused. As she states in the book, "He said I had to and I better not tell." Her father had abused his power as a parent, claiming he had the right to molest her. Then he threatened Tessa to keep her quiet, to keep her from seeking the help she needed and deserved as a small child. She turned to drugs to forget her pain. She was someone's daughter, then. Just as she is now someone's mother. In both cases, her point of view has not been considered. By telling

her story, Tessa reclaimed her power and made her point of view matter.

Tessa's story, and those of other women, helped us make a connection between Dr. Walker's research and something told to us by Dr. Suzanne Dixon, director of the nursery at University of California, San Diego, Medical Center, and a pediatrician specializing in the care of drug-addicted infants. "For women who become involved with drugs, depression is a significant factor during their drug addiction, following their drug addiction, and preceding their drug addiction. Children being reared by mothers who remain chronically depressed," says Dixon, "have developmental difficulties." We began to see how the legacy of abuse and addiction is passed down generation to generation.

There are those among us who seek to blame, punish, and even jail pregnant addicted women. Given Dr. Walker's new research, it's time to examine the misogynist assumptions behind targeting drug addiction and pregnancy as the women's problem, and expand the focus to include the fathers, grandfathers, uncles, family "friends," and partners who have contributed to this problem. It's time to examine the desire to put women in jail, rather than into treatment. As counselor Judy Saalinger, former president of the San Diego Chapter, California Women's Commission on Alcohol and Drug Addiction, asks, "If the American Medical Association in 1956 declared that alcohol addiction is a disease, and in June 1967 declared that drug addiction is a disease, then why do we want to put the women in jail? We've got to get this back to a health issue, or we'll never stop it."

We took great care to make sure that this book represents both points of view: the babies' and the mothers'. This book is about addiction, and it is also about women taking back their power, finding recovery, and forging new lives. Throughout the book, you will hear women's strength resonating through the narratives, the photographs, the poetry. We found that the women's stories—across all classes and cultures—demonstrate their courage, humility, and resilience. In listening to their stories, we experienced their

connection to other addicted women along the same path, and their desire to help them find the clearing.

We use our art to speak the unspeakable in *When the Bough Breaks: Pregnancy and the Legacy of Addiction*. The poems, narratives, and photographs in this book crack open the cycle and the silence surrounding the legacy of child abuse and addiction. This is our way of saying *no* to the violence against women, against children, against life.

—Frances Payne Adler and Kira Corser

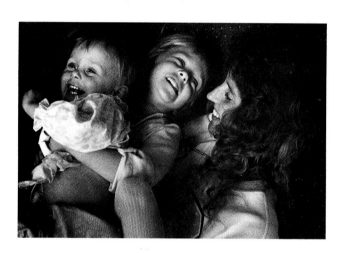

I
Breaking the Silence

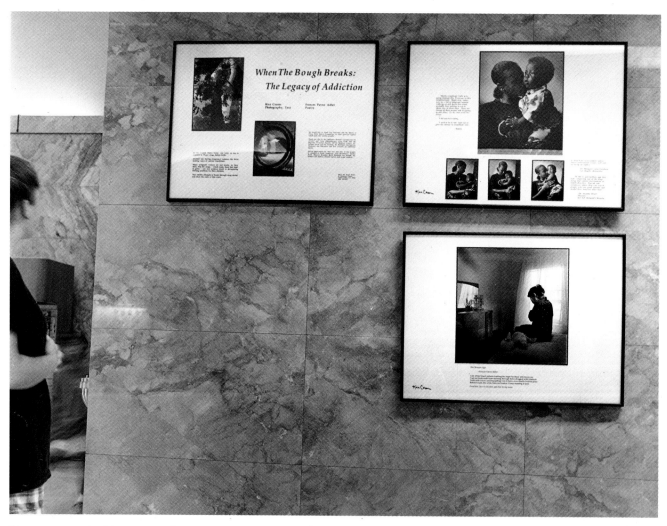

Government authorities attempted to censor
eleven of twenty-three pieces in the exhibition
at the state capitol in Sacramento.

Censorship

A conspiracy of silence wraps itself around the disturbing legacy of child abuse, addiction, and pregnancy. The importance of breaking this silence, which can be as numbing as a drug, was brought home to us the day we faced censorship at the California state capitol in Sacramento.

Our story of censorship began a few days before the opening of our exhibition, *When the Bough Breaks*, at the capitol in August 1990. The exhibition was hosted by state Senator Lucy Killea and the March of Dimes Birth Defects Foundation in an effort to bring more awareness to the growing problem and to educate the public—including legislators. Senator Killea's office called to inform us that the chief of the Office of Buildings and Grounds had all twenty-three pieces from the exhibit lined up, leaning against a wall, and was delaying the hanging of the exhibition. We were told that three government representatives had walked from one piece to the next, arbitrarily deciding, "This one is acceptable, this one is not. This one is obscene, this is not." We were stunned to realize that the exhibition—and the many voices that tell the whole story—were being silenced, censored. We immediately contacted the American Civil Liberties Union.

Half of the exhibition was "not approved" by the Office of Buildings and Grounds, which is responsible for "checking" all art to be exhibited on the first floor of the capitol, directly across from the governor's office. Photographs, poetry, personal stories, and statements were censored from the exhibit. The most unbelievable statement—and fact—censored from the exhibition was a family counselor's quote: "Alcohol and drug addiction is a disease."

The day of the exhibition's opening, we arrived in Sacramento and walked the long hallway where only half of the exhibition hung. We photographed the wall with its large gaping holes, staring and silent. The great care we had taken to be sure that the exhibition represented both points of view—the babies' and the mothers'—was shattered by the censored images. What the government officials declared "acceptable" in the exhibition supported only the babies' stories and clearly condemned the mothers. Amazing. Here we were in Sacramento, and they were telling us that we couldn't tell the whole story, only the parts they wanted us to talk about.

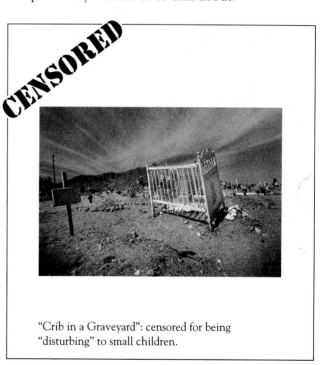

"Crib in a Graveyard": censored for being "disturbing" to small children.

We organized a meeting with the Office of Buildings and Grounds just hours before the opening. It took place at noon in Senator Killea's office. There we sat: Senator Killea behind her desk; two March of Dimes representatives next to her; the two of us, the artists; and a lawyer from the ACLU. Across from us on the couch sat the chief of the Office of Buildings and Grounds, her assistant, and a third government representative in shirtsleeves who did not identify himself and who remained silent throughout the entire meeting. The eleven frames, the censored stories from the exhibition, leaned against the walls, the windows, and the senator's oak desk.

As we talked, the ACLU lawyer quietly took notes. We asked for reasons. "Why were these stories censored?" We were told that our art violated three categories of "section 15567 of the California Code," thereby making these stories unacceptable for the capitol. Nothing political allowed. No photos or poems about drug use. And nothing "obscene."

One by one, they went through each frame, citing the reasons. They viewed the family counselor's statement about drug and alcohol addiction being a disease as representing one point of view in the current discussion in the state legislature: "Should the law criminalize addicted pregnant women or view drug addiction as a disease, and treat them?" The counselor's statement was therefore regarded as "political" and "unacceptable." For us, it was incredulous to think that this was happening in a house of politics.

The poem "Coke-a-Bye-Baby" was censored for its focus on drug words, along with the accompanying photograph of drug paraphernalia. Another piece was censored for its photograph of shooting up drugs. We

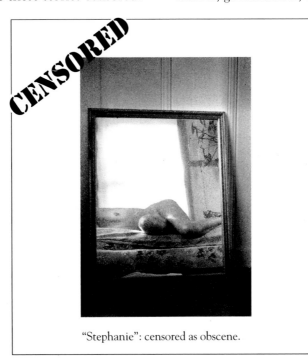

"Stephanie": censored as obscene.

looked at each other and asked, "No images of drugs in an exhibition about drug abuse?" We were told the photograph "Crib in a Graveyard" was censored because it might be "disturbing" to small children walking through the capitol. And the photograph of the drug-addicted mother Stephanie was censored for its "obscenity." Stephanie, addicted to cocaine, down to eighty-five pounds. Obscenity was being defined by the state of her clothes, not the state of her health.

As the censoring continued, the government's collusion in the silencing surrounding abuse and drug addiction became clearer and clearer. How true the words from the poem "No Longer Silent" seemed in that moment: "Just hold your tongue, girl." The fathers, grandfathers, uncles, and family friends who abused children often threatened, "You better not tell." Our government was doing the same.

The Office of Buildings and Grounds refused to budge on its decisions, and never once did its representatives use the word "censored." When we told them about our press conference scheduled for three in the afternoon, two hours away, the three government officials decided they needed to talk privately in the hall. We sat and waited, and a while later they came back to negotiate. They told us we could show anything political, but anything with drugs or nudity was out. We decided not to take a stand on the photograph of Stephanie, which they considered to be "obscene." (This was around the time that Robert Mapplethorpe's photographs were being censored.) We wanted to keep the issue focused on the government's collusion in the silence around drug abuse. We refused to allow the exhibit to be hung without the full picture of drugs and a balance of both the mothers' and the babies' stories. Once

again, there was a standoff. We began to plan our press conference.

A few minutes later, a phone call came from the man in shirtsleeves, who now identified himself as an aide in the governor's office. It was thirty minutes before the press conference. We suspected his boss, California Governor George Deukmejian, would not appreciate newspaper headlines declaring "Censorship in the Capitol." The governor's aide relinquished any further attempts at censorship, and we hung the exhibition in full.

Unfortunately, the censorship tale doesn't end there. The exhibition was scheduled to hang in the capitol for ten days. It was taken down three days after it opened, after we had left Sacramento. The state government's attempted policy of prior restraint with our exhibition was not exposed. Though we were pleased that our exhibition was not censored, we were concerned that other artists showing work in the capitol might not have access to the resources we had, and might be censored. We needn't have been concerned.

A new policy was instated: no longer are art exhibitions allowed to hang along the halls to the governor's office in the capitol.

This firsthand experience with censorship eventually fueled our commitment to create this book, finding one more way to break the silence. We also came to understand more profoundly that if the intergenerational cycle of child abuse and drug and alcohol abuse is to be broken, the whole story must be told.

Frances Payne Adler and Kira Corser

"Shooting Up": censored for showing drug paraphernalia.

Censored

American Civil Liberties Union Blocks Attempt to Censor **When The Bough Breaks** *Art Exhibition in State Capitol Building August 1990.*

Good work she says but the Code she says
Section 15567 she says and she's shaking
her head, this chief of the Office of

Buildings and Grounds.
Not acceptable, she says, her lips
like levers veiling the unsaid

this one and this one and this one and this
they'll not hang on the wall
in the hall of the state

building, not next
to the governor's door.

It rises in us
like frostbite:
we're being censored.

*No photographs of drug
paraphernalia.* (This, an exhibition about drugs)
No photographs of using drugs. (This,

an exhibition of drug abuse)
Nothing controversial or political.
(This, in a house of politics.)

Drug addiction is a disease **Censored**
Coke-a-Bye Baby **Censored**
I was always the good girl **Censored**

16

I wanted to stop using but I couldn't get MediCal **Censored**
My crib in a graveyard **Censored**
My guy and I shooting up **Censored**

My body **Censored** *by cocaine*
down to eighty-five pounds
my ribs, my skin, one nipple showing

And nothing obscene.
obscenity defined by the state of her clothes
not the state of her health

it's the old *don't see and don't say*
what we know to be true
he said I had to and I better not tell **Censored**

not this time, this time we don't have to, this time
we tell, say Tessa and Stephanie and Denise and Marie
Theresa and Susan, Leticia and Christine

Lisa, Melissa, Monica, Karen
Judith, Anne, Marianna, this time
we call in the ACLU

this time, our stories are heard

II
Addiction

Coke-a-Bye-Baby

on the tree top when the wind blows crack jumps over
the candlestick hickory dickory dickory china white
see how they run three blind pakalolo crystal booze
the cradle will speed spliff iced formula tweaking
happy hour this little piggy wasted rig rattle rug
bong spoon razor coke little Jack Horner sits in a
crackhouse shooting oatmeal corkscrew nipple
six-pack when the bough breaks the cradle
will freebase baby powder speedball Jack and
Jill shrooms formula ganja rings on her fingers and
bells on acid falls down steps on a crack and
breaks heroin pacifier hammered toke potty pot
crayons down will come ecstasy marbles snorting
three blind wired freebie freebase humpty horse
horsie rasta diaper dust doll crack crack clock
sock shoot baby cradle and all

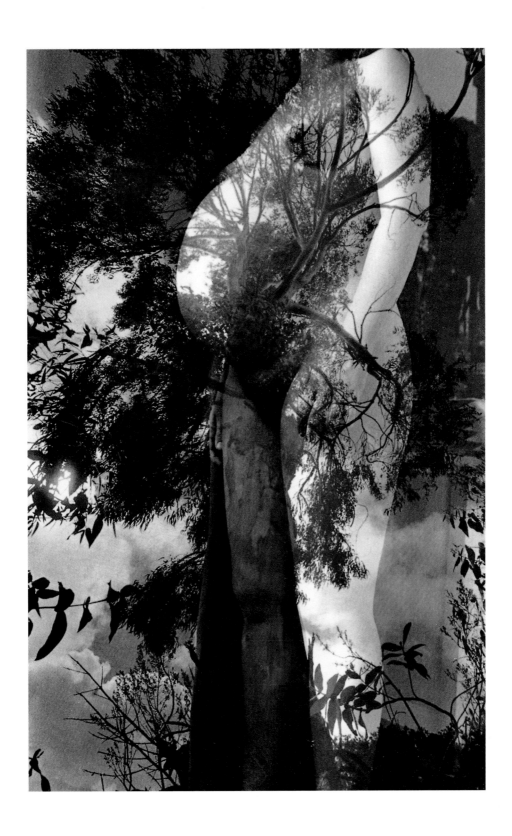

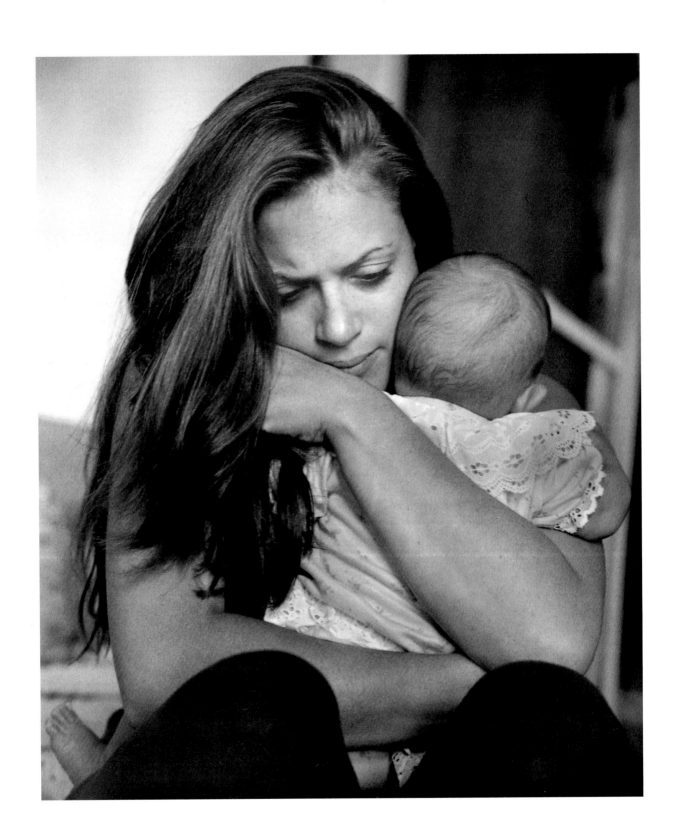

"God Help Me I Can't Stop."

If the American Medical Association in 1956 declared that alcohol addiction is a disease, and in June 1987 declared that drug addiction is a disease—then why do we want to put them in jail? We've got to get this back to a health issue, or we'll never stop it.

— Judy Saalinger, Family Counselor
California Women's Commission
on Alcohol and Drug Dependencies

When I was 11 years old I started smoking pot. I was having emotional problems at the time and this stuff seemed to help me out. When I started doing cocaine and crystal there were lots of reasons. There was my weight, the freedom, the easygoing feeling like you've got it all wrapped up, you're in control of it all.

After a while it just became something I had to do. I mean, I'd tell myself I wasn't going to do any more, wasn't going to do any more. And I'd always do it and I'd always feel guilty and hate myself for it and say, Why can't I stop? I don't know why I can't stop.

I believe it's not a natural instinct for women to want to hurt their babies. Pregnant women don't want to use. They don't want to hurt their babies. I know I didn't want to hurt mine.

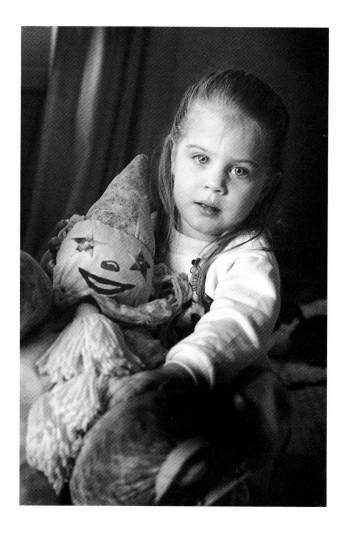

But two days before I had my daughter, I was in desperation. I had a mirror in front of my face, a line on it, a straw in my hand and I knew I was going to do it. I said, "God help me, I can't stop, help me." I started crying. Two days later, I went into labor and the baby was ten days early.

They took both girls away from me in the hospital. I'd been warned about what could happen. I had no idea it would come down to what it had come down to. My aunt set me up to see a counselor at the Clairemont Neighborhood Recovery Center. She set me up in a recovery 12-step program. I've been clean and sober for eight months.

— Lisa

The Women Ago

I am white blood curtains tracking the night for those who know me
I set out backwards from morning through holes drugged with blankets
I talk with voices carrying garbage out to burn, eyes shuffle behind glass
Behind roads, the white lines are broken, I keep wanting to pass.

I am here, face me faceless, you live in my name.

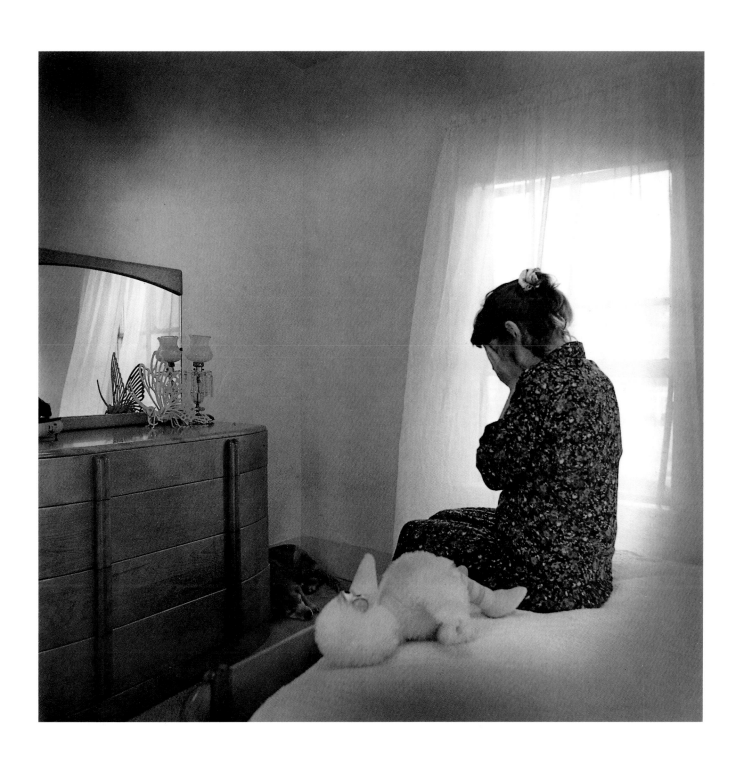

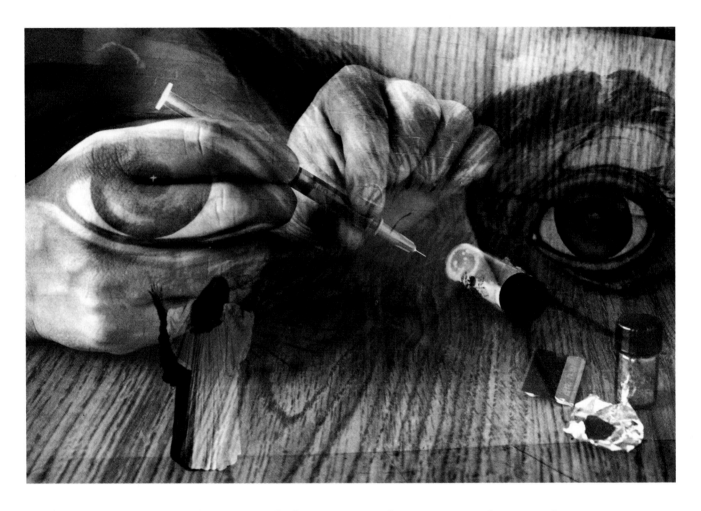

I remember the baby going into kicking spasms, jerky-type spasms, during my drug use, inside of me. I kept saying I was going to stop, was going to stop, but I just couldn't.

—Anonymous

Dust

I have disappeared
behind a costume
of glitter dust
and eleven luminous hands.

Who are you, woman.

I am homeless bones,
tracking the night for flesh
or those who know me.

Black Hole

At night, a woman without eyes
carries a bucket, sloshes water,
washes a mother's wounds.
She walks with me
around white cocaine mountains
through puddles stained
red with birth

I carry my camera
but I can't photograph
the baby's scream.
It rakes my nerves
like fingernails

I can't shoot
the smell of diarrhea,
the babies' bottoms
blistering, as drugs
leave their bodies

In a little girl's brain
a black hole
sucks my heart

—Kira Corser

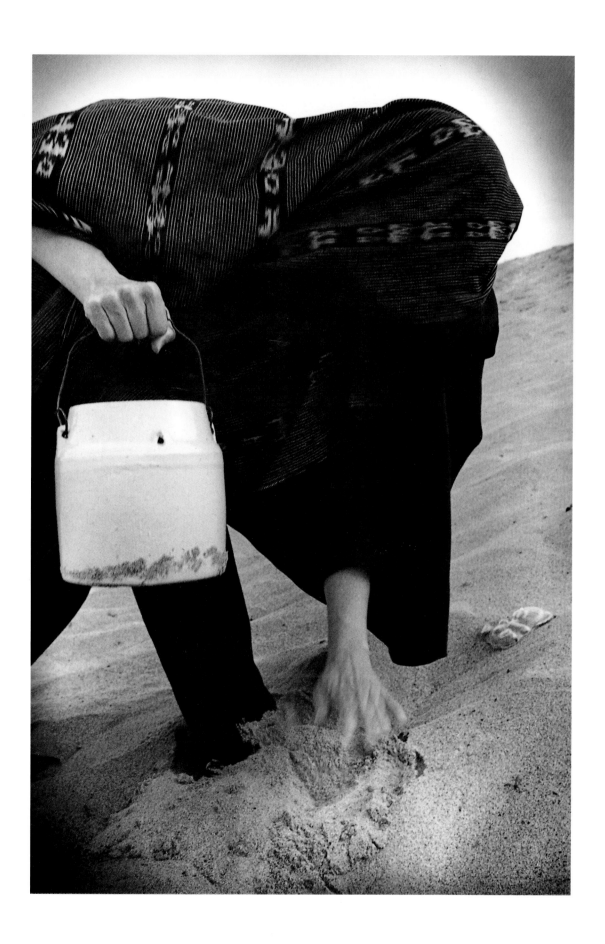

My Power, Giving It Away

I always had boyfriends that drank heavily. Eventually I did drugs. A lot of what I did—drugs, sex, drinking—had to do with whoever I was with. The man in my life. I used to turn over my will and my life to whatever man I happened to be dating or was married to.

—Monica

What is it for a woman to wake
in a sharp sweat

What is it for a woman
turning mirrors
to the wall at night
so her face won't seep out

"We used to have this little cabinet...."

His mom lived right next door to us. She knew
but she was in denial. We used to have this little cabinet,
where we kept our rigs and dope, and she would sneak
into the room when we were gone. She would take a
needle and she'd burn the needle and poke holes in the
rigs. So when we would fill up the rig, we wouldn't get it
all. Don't know why she didn't just get rid of the rigs.
We would just ignore it, we knew it was her.

She even brought Steve back some morphine
one time from Tijuana because he didn't have any dope
and she had gone there to get her teeth fixed.

—Judith

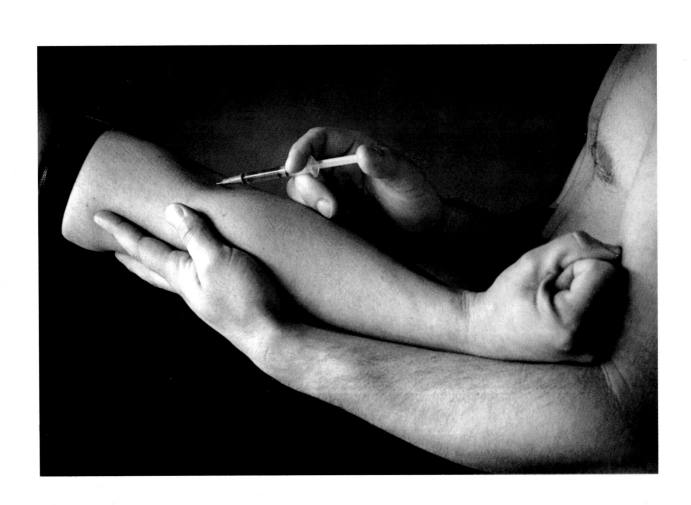

A major underlying issue with drug-dependent women is the relationships and lifestyles of the men they choose to be with, and the difficulty they have giving that up.

One woman told me she didn't know why she had an incredible attraction to this abusive man. She said, "My skin crawls when I touch him." There's a lot of denial in drug use, but there's also the denial of what's going on in their relationship.

—Liz Hersch, Coordinator
Parent Care Project

Alcohol use during pregnancy remains the leading cause of preventable mental retardation.

—Kathy Kneer, Director
Birth Monitoring Program
March of Dimes Birth Defects Foundation

MEDICAL NOTES

In 1989, $9.1 million was allocated by the National Institute on Alcoholism and Alcohol Abuse for research on the effects of alcohol on the fetus; only $3.1 million was allocated for treatment and prevention for women addicts.

—Paula Roth, Author
Alcohol and Drugs Are Women's Issues, Vol. 1

For every dollar spent on treatment services, $11.54 is saved in social costs.

—Clarence Lusane, Author
Pipe Dream Blues

"The babies frown, they moan. Some are afraid to open their eyes."

—Samantha Storey, Nurse
University of California, San Diego Medical Center

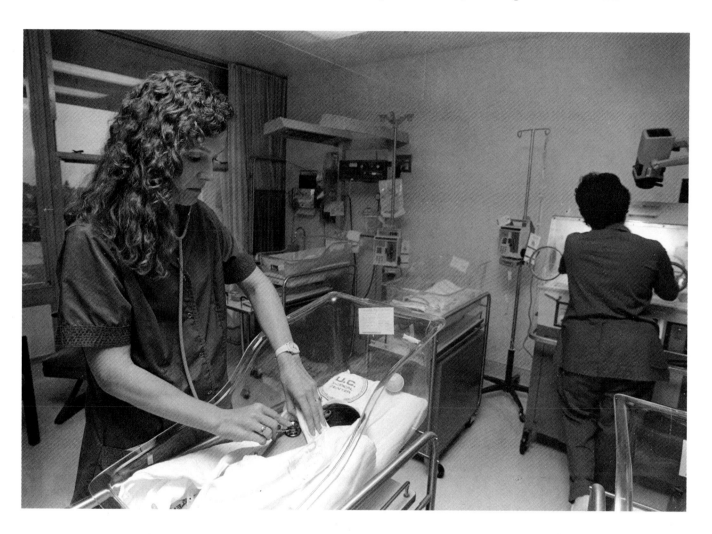

*Most of the mothers are sincere in not knowing what they've done to their babies.
I think they feel helpless too. They need people to help them realize what can happen.*

*I can't even imagine how difficult it must be for them. A mom who has used drugs and
who comes from an abusive family doesn't have the problem-solving skills to deal with
a baby like this.*

—Patti Garretson, Counselor
Pediatric Nurse Practitioner

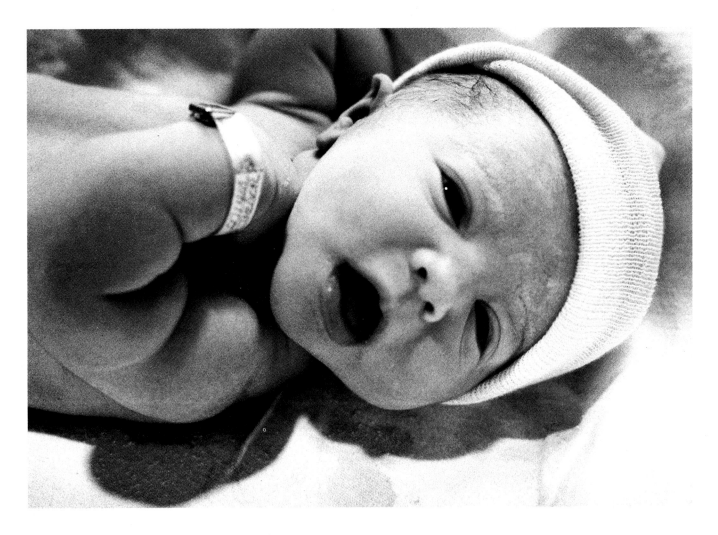

We have a baby in our nursery right now, she is so beautiful. You look at her and think, "What's she doing here?" She might have holes in her brain because her mother was cocaine-addicted. It's so awful, you have this absolutely beautiful baby with something that will affect her life certainly.

We have another tiny baby in our nursery, also born to a drug-addicted mother, who I just can't believe is still hanging on. His lungs are damaged, his heart. And we think

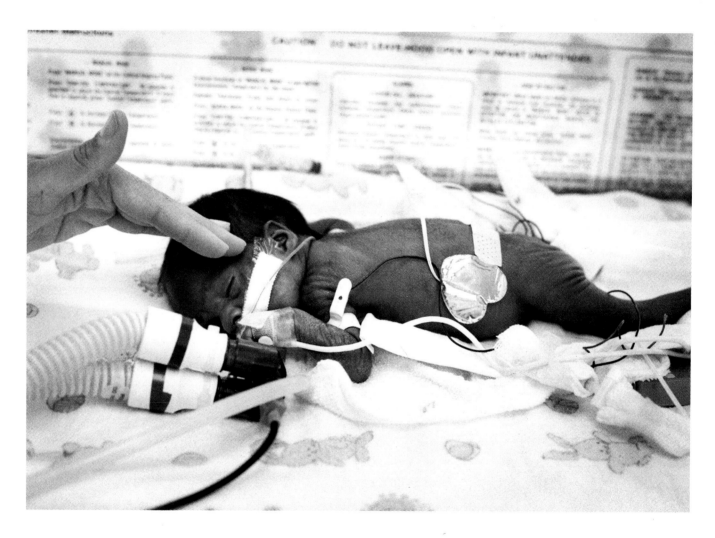

to ourselves, "*Well, there we can see the effects of drugs.*" *Some of these babies are so irritable that any kind of touch is not soothing to them. It's very distracting, annoying to them. Drugs can make a baby so irritable, so fussy, that even human touch is not a consolation.*

—Ella Goldwebber, Social Worker
Neonatal Intensive Care Unit

Caves Carved

The drum of all my years
like gravel
rolling downhill, down
through caves carved (when?) in my bones

who screams using my voice

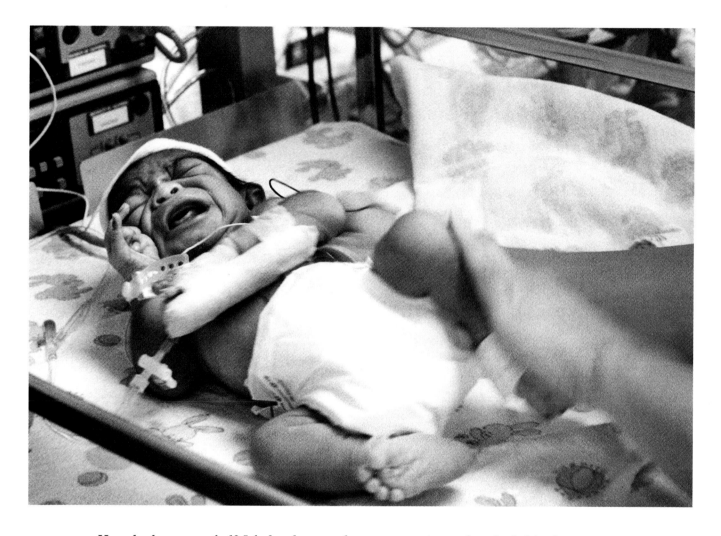

How do the nurses feel? I feel sadness and anger, sometimes, that the babies have to suffer.

I adopted a baby girl who was born exposed to drugs. She's beautiful, special. I'm hoping she won't have any problems.

—Artis Cobar, Nurse
Hospital Nursery

III
Mothers

Between 60 and 80 percent of substance-abusing mothers have been sexually or physically abused at some time in their lives.

—Lenore Walker, Psychologist
Director, Domestic Violence Institute
Denver, Colorado

"I had to be the caretaker."

I got left with being a mother to two brothers, at 9 years old. One brother is eleven months younger than me, the other is seven years younger. My dada and my mom got divorced, so I pretty much had to be the caretaker.

Later on, things happened with my dad. I got sent to Hillcrest Receiving Home—right before I started using—because my dad had tried to molest me. When he tried to do that, I had to hide in fear all night. He tried it twice. He just attempted it, no penetration or anything. I lived in fear. He was drunk. He wanted to kill me.

The next day, I ran away from home. I was 12 years old, going into the eighth grade. I ran away to my girlfriend's house. Her father's a cop. It was hard to press charges, especially with someone who denied it, and who never showed up in court.

That's when I started smoking pot and I realized, oh gosh, I could get rid of these feelings. I liked being the different person I was when I was using. It made me feel like I could do anything, be anybody I wanted to be. I certainly wasn't happy with the person I was. I liked not being able to feel. I liked it.

Then they placed me with my mom, who lived back East. My mom's an alcoholic and a drug addict, emotionally not available, not caring. She was physically abusive, too. That's when I started drinking—drinking to get drunk.

I tried to live with my mother, but we argued all the time I was using. I was never there. I got to be just like her. And I swore that I'd never be like her. She did the best she could with what she had, but when I look back, there's still a lot of anger.

I didn't start using speed until a year later when I came back to the West Coast. Years went by—using—and my life became unmanageable. For a year and a half I was homeless. I remember hanging out on the street being pregnant. We were sleeping in the orange groves. I asked my dad to take care of my son. He took him, and turned me in.

Now I'm learning how to be a parent. I never got love and stuff when I was a kid. I didn't know what love was. I'm trying to break the chain of what I learned from my parents, what I thought was OK, but what made me feel really lonely, real alone.

I don't want my kids to grow up like that. My son, he doesn't directly remember. But he indirectly remembers what I was like when I was using. I wasn't there for him. He can't put words to it, like, "OK, Mom, I remember you were really fucked up, you were on drugs." He doesn't understand that. But what he does remember is me being real angry a lot.

We're both working on it, both going to counseling. And I'm going to college because I want to get my degree. I want to work with recovering addicts.

—Tessa

Tunnel Vision

*People don't understand when I try to be honest
and tell them, "Yeah, I was an abuser,
but yet I was abused."
They don't understand that.*

—Tessa

at what time in the tunnel
 did the gentle inhabitants of her body pack up and leave
at what time did her father's beer take the house hostage
 and she learn to live with too much sadness
 he said I had to and I better not tell
at what time did steel plank itself beneath her skin
 and ropes begin to bind her blood

what are these ropes, and how long the tunnel

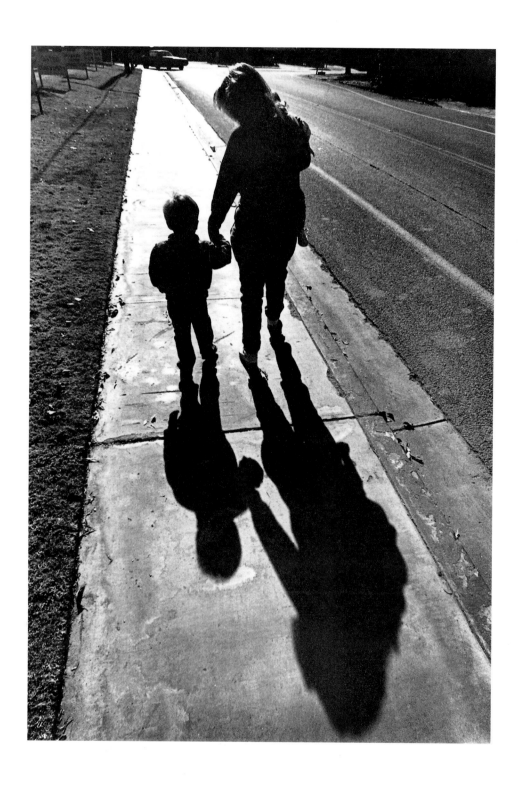

"I wanted to be someone else."

Only once do I remember feeling powerful. I was four, no, five, and my dad sat down with me, took out his work boot, taught me to tie laces.

Seven years later he raped me. I wanted to be someone else, to forget. I wanted not to feel, to disappear. One day I looked in the mirror. The drugs were literally eating me.

— Stephanie

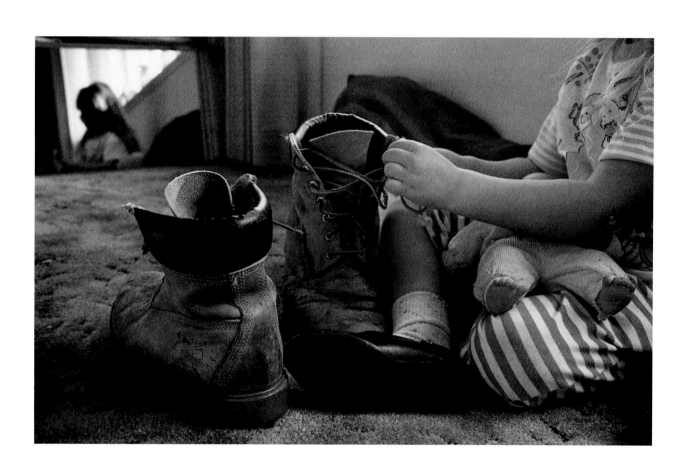

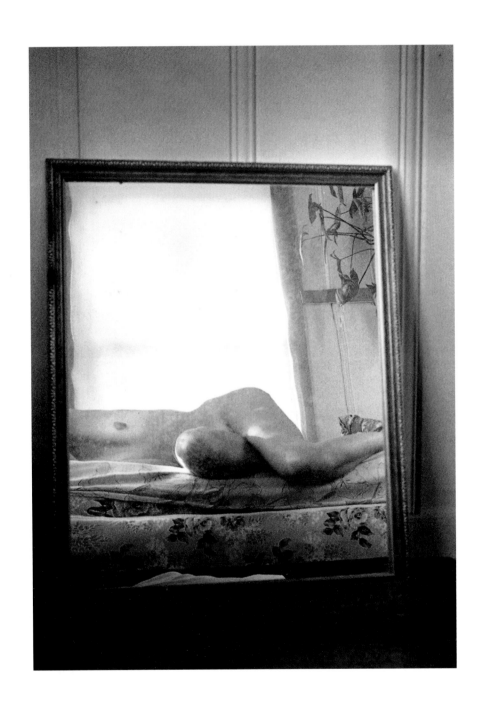

No Longer Silent

No rope, no razor,
no cigarette burns,
just *hold your tongue, girl.*
My tongue a rope
that is untwisting
a rope knotted to silence,
no longer
bound back down my throat

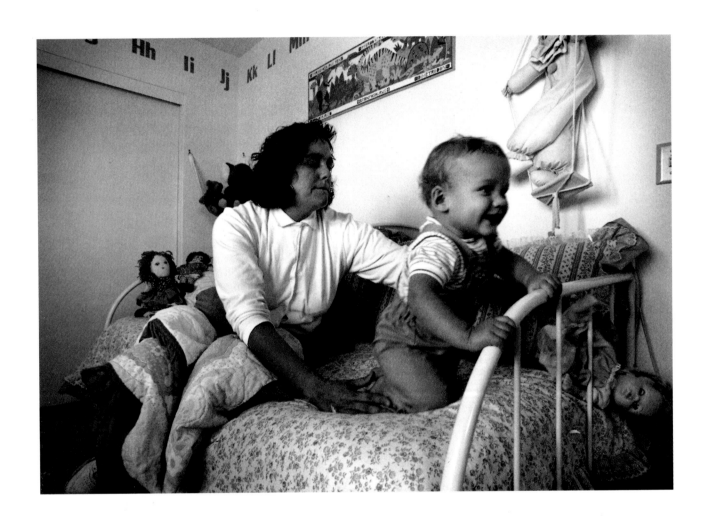

"We were wrong in his life."

At a very young age, I began to drink. My mother drank and my father drank.

My mother was ill and confined to a wheelchair and sometimes confined to her bed. My father was very successful. He would come in drunk every night, begin to rant and rave. He was horrible to my mother, who was unable to move and eventually unable to talk well enough to defend herself.

He would just come in calling her names, blaming her for everything that was wrong in his life. Blaming her for us kids, that we were wrong in his life.

—Christine

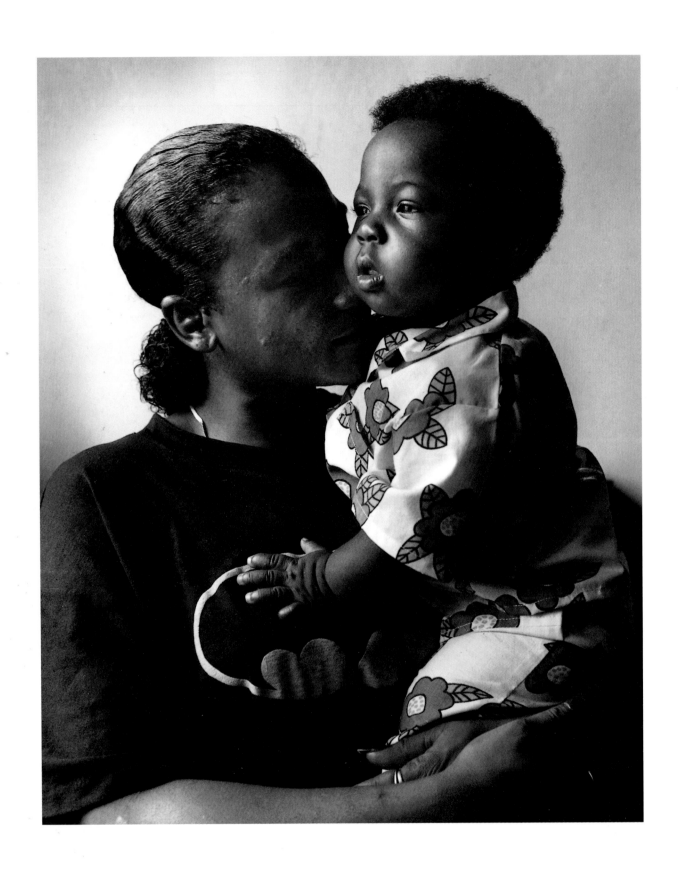

"The man with the drugs."

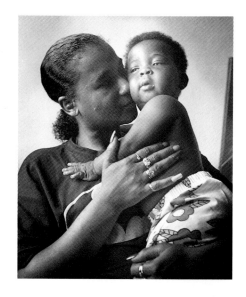

This was my first time using drugs with any of my pregnancies, and I've got three kids. I tell people, if I were you, I wouldn't smoke while I'm pregnant.

In the incubators at the hospital, I've seen babies having the shivers. I thank the Lord mine came out healthy. They said he had drugs in his urine when he was born. They took him away, gave custody to my mother. I remember crying because it scared me.

I had just gotten out of jail, just ran back into the wrong crowd. My friend talked me into it. My best friend. You know, instead of positive thoughts, your friends give you negative ones. They might come up to you and offer, saying, "Well, hit this," and you might say, "Well, I don't want to smoke it right now." And they might say, "Well, go on and hit it." And then you end up taking one puff, and one puff leads to another. It's worse with coke. You end up with no money, nothing to eat, no kids.

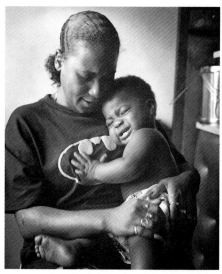

I stay to myself right now. I'm in a recovery program. I have a couple of friends that don't do drugs. They live out of this neighborhood. I want to move. I want to go back to school and finish hair school, become a cosmetologist. I have about a month and a half to go. I've got to finish, straighten my life out. This is my chance right now.

I wish they weren't even invented—drugs. I used to do it too. Run to give my money to somebody else.

Mostly everybody I talk to is going through this. Everyone in this neighborhood. Right now, today, you see a lot of pregnant women walking up and down this street, probably had nothing to eat in about two or three days. They are taking all their money and it's going to one place—to the man with the drugs.

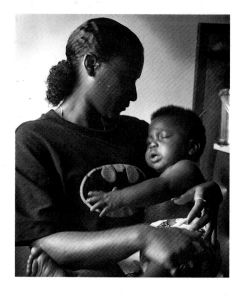

I bet you he's eating.

—Karen

"I had no idea."

When I was pregnant, I was drinking and smoking pot. No one told me not to do it. I had two miscarriages. It turned out later that I have a condition called gestational diabetes. Drinking is about the worst thing you can do.

I lost two children in that marriage. They were very serious miscarriages. The first one, I gave live birth to the baby. I hadn't had any prenatal care. I went to the doctor when I was five months' pregnant, and then, a month later, I miscarried. The baby lived about six hours and died.

That had a devastating effect on my marriage. I became pregnant again within a year. With this baby, I had a placental separation at six months. The baby was stillborn, and they had to do a fetal extraction. It was very, very painful. I have no memory of it, except waking up and being in incredible pain, and in a twilight sort of dream.

I had no idea that my alcohol had anything to do with it.

—Marie

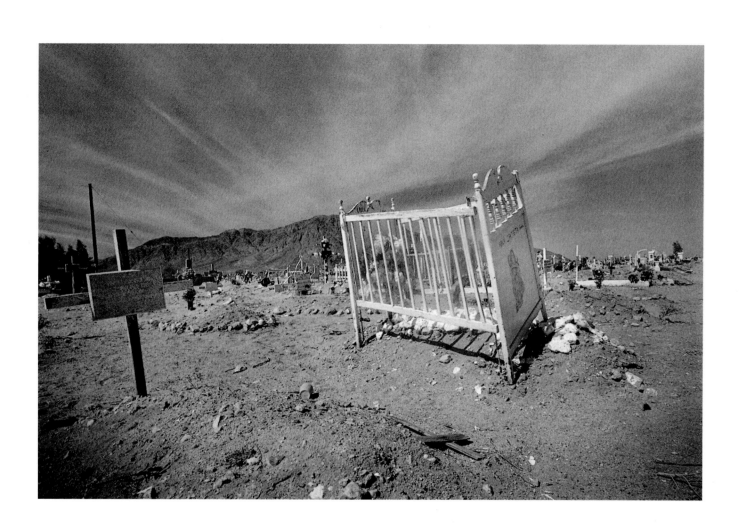

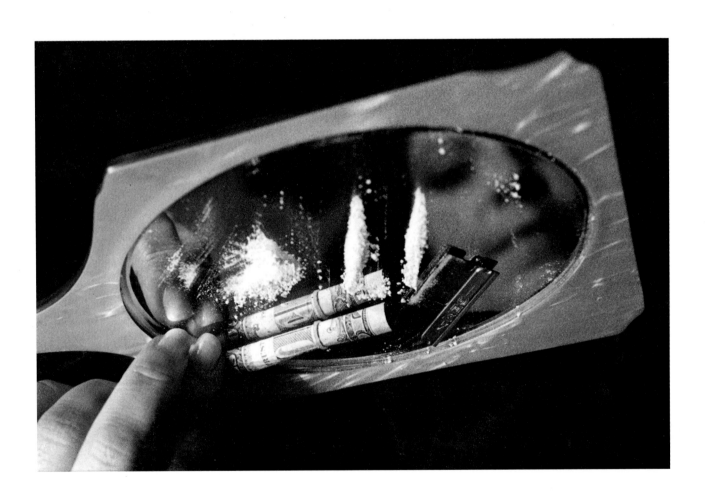

MELISSA

"I was always the good girl."

I was 12 when I started smoking pot, 18 when I started snorting crystal. I was living in Del Mar with my parents, I was my mom and dad's little girl. I had three sisters and one brother. I always got straight A's. I was the good girl out of all of them.

I'd never heard of crystal until I met Paul. He introduced me to it, and I started snorting. He'd been shooting up since he was 12. It took about a year, and I started slamming it. After I moved out, I would go back to my parents' house and steal stuff from my dad's garage to trade for drugs.

I moved in with Paul, with his mom and dad. He was a jeweler, making jewelry for crystal. He had a shop set up in his room. Then I found out I was pregnant with Bethany, she's my oldest. I just hibernated in the bedroom in his shop for all those months until I had her. I used throughout all my pregnancy, but Bethany came out OK. It's like she was charmed.

When CPS [Child Protective Services] first got involved in our case, it was when I was pregnant with Laura. I was six months' pregnant, and I was slamming crystal. I got high a half-hour before I went into labor.

I didn't want to go to the hospital because they would find out I was using drugs. So I went instead to my connect's house and got some weed.

When I went to the hospital they asked if I did drugs, and I said, "No, but maybe I smoked a joint." I was in big denial. I didn't want to admit it. They could just look at my arms. I had track marks up and down my arms.

They had to do an emergency cesarean on me and I almost died, and the baby almost died. She weighed three pounds when she was born, and she was on a heart monitor for over a year. I had to give her special medication. And I was still using, doing that.

Then the court ordered me to stay away from Paul because he was a bad influence and he was my main connect, he always brought the drugs in. They court-ordered me to stay away from him. I didn't listen because he was my main resource. CPS would come over, he would go out the window and come back after they left.

The kids got taken away in October. They went to a foster home. They were almost adopted out. That's when I decided to do something about my problem.

You know, you just don't know what you're doing. I didn't know what I was doing. I just knew I wanted to get clean. I didn't know how, I didn't know I could get clean, I didn't know I had a choice until I started getting help. I've been clean eleven months.

I went into Kiva* thinking that Paul and I were splitting up because I knew what I had to do. I had to get clean for me. I went into Kiva thinking I was never going to see him again. Then all of a sudden he started calling and telling me he was clean. He's been clean a year this month.

—Melissa

*Kiva is a recovery program for mothers that lasts six months to a year. The program includes living in a home with other mothers, learning parenting skills, and working to be reunited with their children. Kiva is also a Hopi word for ceremonial house.

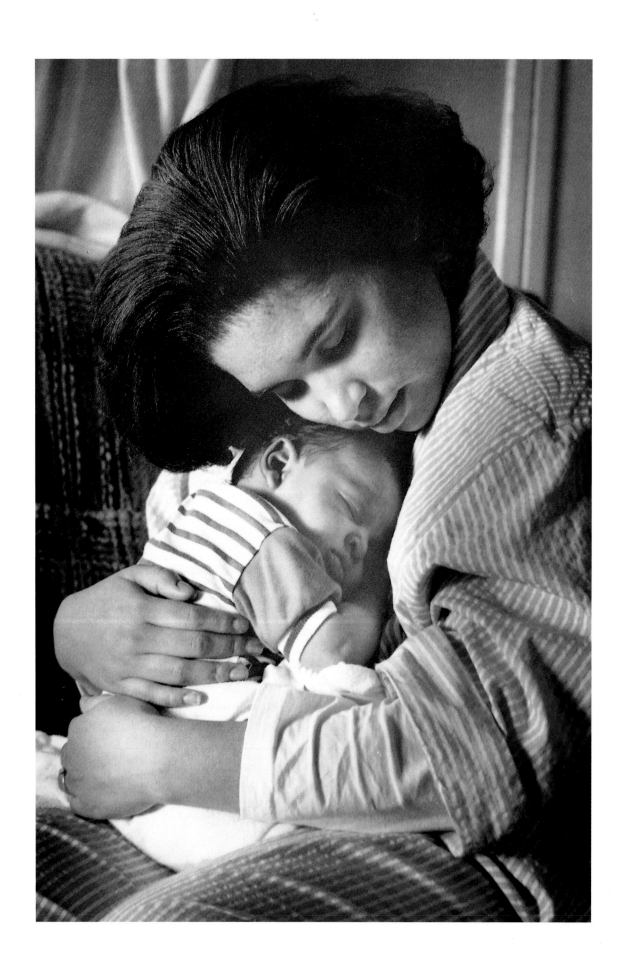

"How do I know I'm a dope fiend,

or, even when I do, and I called forty places to get help, they wouldn't take me because I only have MediCal* insurance."

I take a cab over to where Johnny works. I didn't know how I was going to pay for the cab. Johnny gets in and says, *Where have you been?* He's thinking, praying that I was with his parents. He's praying that I didn't go out and do the same thing again.

I said, *I spent the money.*
He said, *No, no you didn't. No you didn't, Theresa.*
I said, *Yeah I did, I got high.*
You're pregnant, how could you? he said, like he doesn't understand this, he's never been around this. *You're pregnant, how could you do this to our child?*
I told him, *I'm sorry, I'm sorry.*

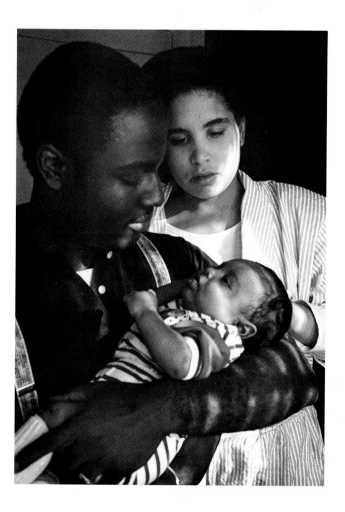

I don't know why I did it, I'd try to explain to him. He said, *I'm getting a divorce, I'm getting a divorce.*

When I'd go to him for help, he'd say, *What? You can't stop? What are you, a dope fiend?* He didn't know what help to give me. The whole thing was crazy. We were going to get a divorce.

I told myself, *God, I have this problem, and I need your help.* I didn't know what to do. I didn't want to lose him. He was my first love. I had everything.

I said, *I'm way beyond helping myself. I'm going to get help.* I picked up the phone book. I called all these places. All they could tell me was, *Do you have any insurance? No, I don't have any insurance. Well, I'm sorry we can't take you.* I said, *Well, I have MediCal. No, we don't take MediCal.* I called over forty places.

I'm thinking, *Well, I need help.* I finally got ahold of Recovering Addicts Anonymous. I said, *How do I know if I'm a dope fiend?* She said, *You mean addict.* I knew I wasn't bad, I just knew I was an addict. I knew I had a sickness.

Every day of my life I will fight it. I will always fight it. I would rather fight than lose. That's like saying, *Take my baby, take my husband, take my wonderful life, take what I do have, take the roof over my head, the clothes on my back, take it all—'cause that's what going to end up happening, and that scares me to death.*

—Theresa

* MediCal is California's equivalent of Medicaid, a program to provide state-funded medical services for people with low incomes.

IV
Children

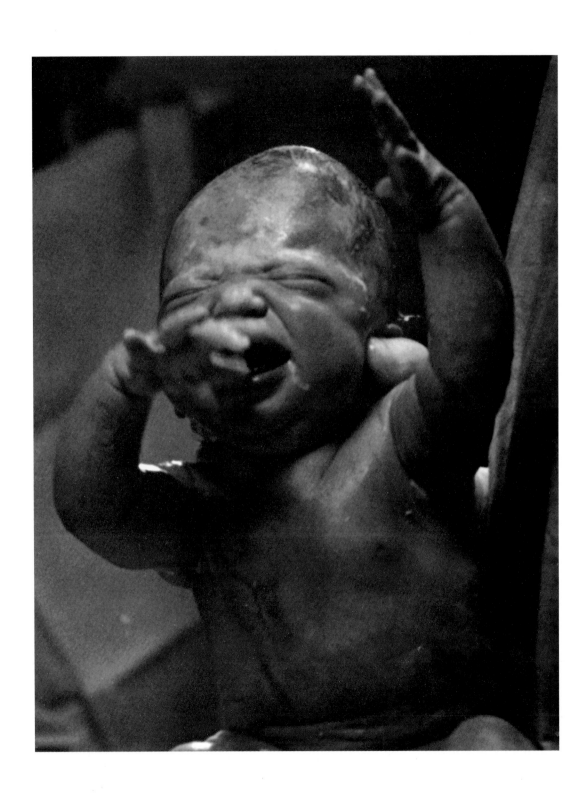

Entering Ceremony,
the Baby's Own

When she came she came with words like new acorns.
Use them, they said, to seed your footprints,
to open the glass fence.

She floated her hands like air along the bloodcoil,
filled her fists with all they had sent with her,
but it wasn't enough. What did they know of

white dust and a map mismarked

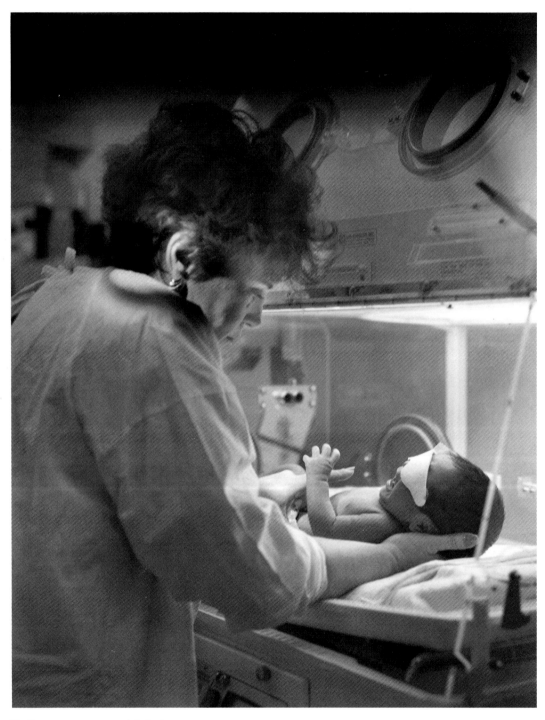

Dr. Dixon examines a sick baby born
addicted to drugs.

The problem of perinatal substance abuse has reached epidemic proportions nationwide. Pregnant women from all economic and ethnic backgrounds are using alcohol, cocaine, heroin, and crystal methamphetamines.

Cocaine, for example, constricts the blood flow to the fetus, which can cause hemorrhaging and leave holes in the baby's brain tissue. A significant number of these babies have developmental problems, behavioral difficulties in preschool, and difficulty learning when they enter a formal school environment.

We now know that the school difficulties may in some cases be caused by, or in other cases made worse by, turbulent home situations where drug addiction hasn't received treatment and the underlying roots of drug addiction have still not been addressed.

I think the issue is: how much is it the drugs? And how much is it all the postnatal turbulence? Most children with prenatal substance abuse—if they're given appropriate support for development: love, and the basics of food, shelter, and health care—do all right.

The trouble is, in so many of these children's lives, the drug abuse is just part of a long list of adverse conditions, like poverty, lack of health care, and lack of consistent parenting—either because the parent continues to be involved in drugs, or because the mother is depressed and psychologically unavailable.

We now know that in women who become involved with drugs, depression is a significant factor during their drug addiction, following their drug addiction and preceding their drug addiction. And we also know that

children being reared by mothers who remain chronically depressed or episodically depressed have developmental difficulties. So, whether the school difficulties are caused by this or the brain abnormalities is unclear.

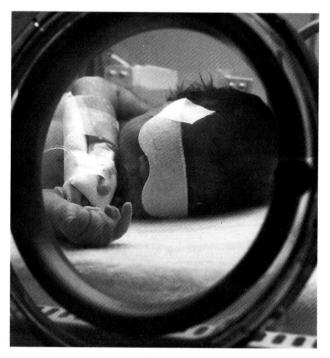

A soft mask shields the light from this drug-addicted baby's eyes. The incubator keeps her warm.

There is recovery in this population, provided they're given the support they need. We have to realize that our interventions have to be with the children, with the families, and with the social systems that adversely impact this whole situation.

—Dr. Suzanne Dixon, Pediatrician
 Specialist in drug-addicted infant care
 University of California, San Diego, Medical Center

The Juvenile Division of San Diego Superior Court has seen an 86.4 percent increase in the number of child abuse cases over the past six years. Substance abuse shows up in at least 70 percent of the cases that reach the court's docket. You can't talk about child abuse without talking about substance abuse. The two issues are so linked now that those of us who are in child abuse work also have to be experts in drug abuse.

—JoAnn Knox, Social Worker
Director, drugs and child abuse prevention program

If the mother is a prostitute or trading sex for drugs and someone comes in and says, "Oh, you've got a cute 7-year-old daughter. I'll give you enough money that you can buy drugs for a week if you let me have your daughter for about an hour...."

I think that when anyone is that desperate for drugs and you've got something to trade— if you've got children and you've got some sicko people that will give you money for your child to abuse in some way—I don't think that the maternal instinct or the paternal instinct is so strong with a person diminished by drugs that they could not accept that offer.

—Anonymous Social Worker

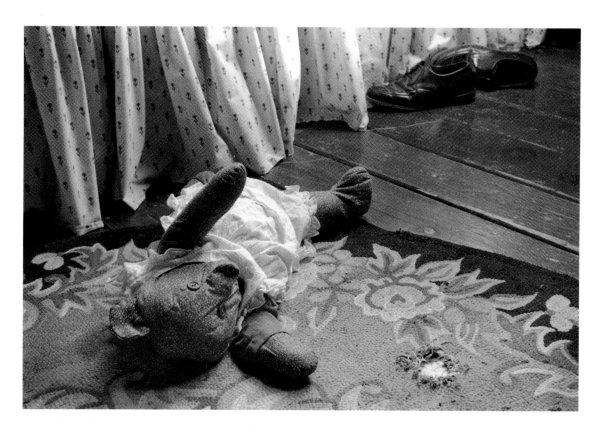

My particular theory, from my experience, is that most addiction to drugs happens because the mother, as a child, has been physically or sexually abused and that's one way of dealing with the pain.

—Ella Goldwebber, Social Worker
University of California, San Diego, Medical Center

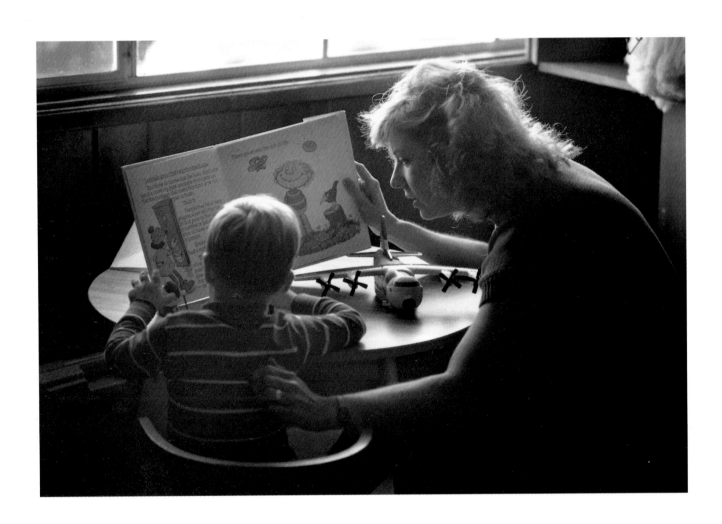

The insecurity. You could close the door slightly and my son would think no one was ever going to come back for him again. He'd throw tantrums, hold his breath, put his head in the toilet. He was different from other kids.

We adopted Tim when he was about one week past his first birthday. He'd been living with his mother, who was a heroin addict. When she was in prison he would stay with his grandmother.

The 16-year-old baby-sitter that took care of Tim before we adopted him told us Tim had been locked up for three days in the apartment. When she went to check on him, because she "couldn't stand it any longer," she found Tim lodged between the bed and the wall. She said that his mother also left him in the car all the time for parties. Or, if he woke up and was crying and she couldn't stand the noise, she'd just pick him up and throw him across the room. Tim had to be hospitalized twice.

Tim's mother was 19 when he was born. She just couldn't care for him. Because she had to buy drugs, she didn't have enough money for diapers. It took four days to get the urine smell off him. I don't think he'd ever had a bath. His bottles had fungus growing on them.

And yet the mother was real sweet when we met her. Kind of an innocent. Her girlfriend, the baby-sitter, said she was real smart. A straight-A student at one time. She was raped by her stepfather when she was about 10 or 12. She decided to leave when she was 15, to make it on her own. Prostitution.

—Rachel Green
Adoptive Mother

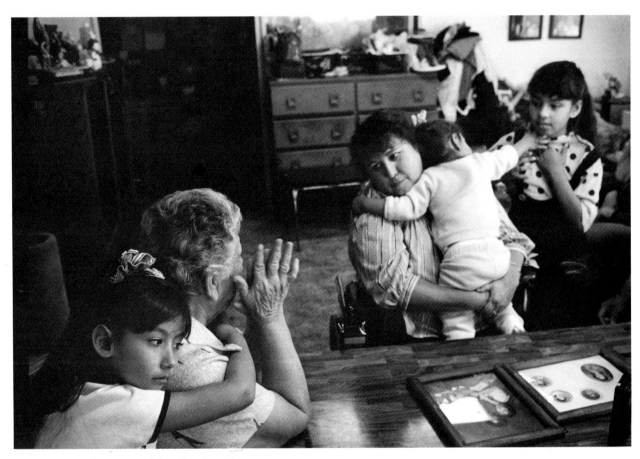

Great Grandmother Ana and Grandmother Gloria
caring for the children.

*At first, social service took the kids away and put them mainly in foster homes. We got
them to let us utilize relatives' homes whenever possible.*

—Margie Davis, Founder
Grandparents Offering Love and Direction (GOLD)

I couldn't break the system, get custody of them. That was the hardest thing. I was willing, but I couldn't get them. I needed help. I heard about this group of grandparents on TV, so I went and they helped me get custody....I thought I was the only one, but there's lots of people.

—Geraldo, Grandfather

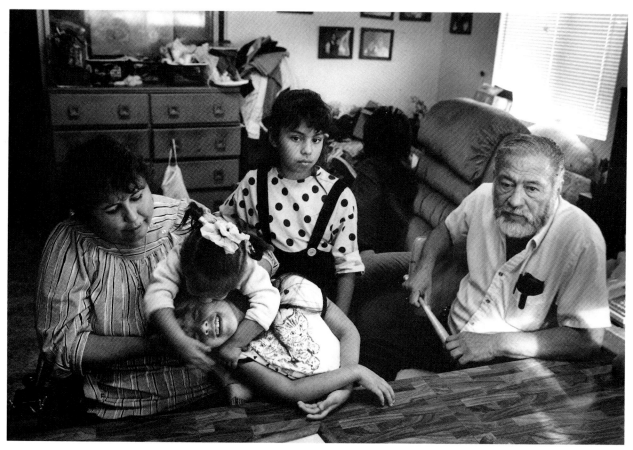

Grandmother Gloria and Grandfather Geraldo
with their grandchildren.

We called several times, and they said as long as the kids don't say anything, there's nothing we can do....Then Leticia finally spoke out at school.

—Gloria, Grandmother

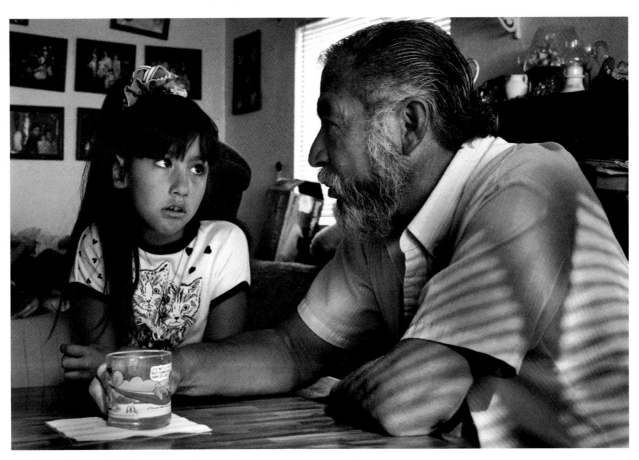

Rosalva and her grandfather.

"You Don't Want to Hear It? You've Got to Hear It."

My daughter's kids have been here for two months. She got hooked on drugs. She was taking crack, crystal.

When the police took her to jail, the school held the kids so they wouldn't come home and have to see what was going on.

This had been going on for quite some time. My daughter's got a home, I had bought her a home. It's just four or five houses down the block. And she was having all her friends come in there.

My wife would take over food for the kids because everybody who was there would eat the food and not give any to the kids. We set a rule: no more giving it to them. If the kids were hungry, they would eat here at the house.

The kids were not going to school. They were taking care of each other. This one, Leticia, her grades were going down. So the school started asking questions. And I was surprised she was the one that told the school that her mother was doing drugs.

Leticia loves her mother, but the only time her mother communicates with her, the only time her mother loves her, is when she's in jail. When I tell my granddaughter this, she wants to walk away. I tell her, "Don't go away. You don't want to hear it? You've got to hear it. Come here. The only time your mother loves you is when she's in jail."

When Leticia's mother was just in kindergarten, my first wife took all my eight kids back to Texas. Then the court took them away from her because of the same problem. So they gave me custody.

My mother here, she's going to be 80, she doesn't think this is fair for anybody. It's not fair for us, she says, it's not fair for the kids. Parents should be responsible for their kids, like she was responsible for us.

When my daughter was a little girl, my mother often took care of them, she used to cook for them. She remembers her being very shy. She didn't talk. You couldn't make her talk. You couldn't make her do anything.

—Geraldo

This Act of Courage

she slipped *I will tell* into her books the morning
she ran down the stairs, off to school without
combing her hair

she walked it growing the sidewalk to school
into faces of her sisters swallowed with hunger,
her mother's morning marijuana locked in their hair,
Rosalva and Irma and the small one, not yet two, and
the needles, her mother's, she picked up with a rag

she wore it like armor when she pulled open
school doors, *and I will keep us together,* she said
and under her skin, the prickle of great-grandmother
Ana and her seasons of cattle, of seven
flags of Laredo grandfather had given her,
of three hundred years of Rodriguezes in Texas,
and the love for her sisters, their circle of steel

The girls were crying, they were hungry, I didn't know what to do. I went to school, told them what happened at home...that my mom was using drugs and we were hungry, and we didn't have food in the house.

It was a scary thing to do, to tell. I was scared we were going to be taken away and separated. That's why I never told anybody.

—Leticia

Preschool teacher Candis Kolb deals with the emotional
needs of the children in her special education class.

I had a little boy in my class. He always had a green runny nose. He needed love so bad I used to spend extra time after school pretending we were working, just so I could give him some attention and love.

One day, one of the teachers was showing the class drawings of different houses. Tyrone was usually silent, but this day he kept saying, "That's my house," and pointing. The teacher said, "Is this what your house looks like?" He said, "No," but repeated, "That's my house." He finally pointed to the space under the front porch. That's where he slept some nights.

His mother would get mad and lock him outside at night. This is a five-year-old. His aunt called the school and told us what was going on. The school would call Child Protective Services. They said, "There was food in the house," and left him there. One morning, Tyrone woke his mother up to take him to school, and she beat him for disturbing her. Tyrone's mother finally pulled him out of school. She felt the teachers caused her too much trouble. She said, "He's no good."

—Candis Kolb, Preschool Teacher
San Diego School District

The kids used to scrape the chalk dust out of the chalkboard and, in the schoolyard, they would wrap it in paper like a joint or cocaine. They used to stuff wads of play money in their pockets. They were pretending they were dealers.

After the Thanksgiving holidays, my class discussed the things they were thankful for, and the things they were not thankful for. On the list of things they were thankful for, *families* was foremost, then came *dogs, goldfish, birds,* and *turkey*...bright idealistic things. On the list of things they were not thankful for, almost all put *drug use, crack, cocaine,* and *guns*. All of the kids said they wanted an end to guns. These are 9- and 10-year-olds living with the daily fear of guns, of violence. There have been shootings in our schoolyard.

One little Cambodian boy in my class was accosted by another child with a gun on his way to school. The boy couldn't tell me about it; his parents informed the school. One girl, Anasa, told the class that she spent Thanksgiving on the floor of her grandmother's bathroom. They were hiding from the drive-by shootings.

Most of the children I teach are living below the poverty line, and drug use is a definite part of their lives. I question which came first: the drug use or the despair.

—Laura Barnett, Fifth Grade Teacher
Oakland, California School District

You can walk in any classroom and you're guaranteed to find four to five kids from drug families. In the second grade the kids are playing drugs. They say, "My mom's trying to break the habit." "My uncle sells it."

—Elaine Armour, Grade School Teacher
Los Angeles School District

Out of nine or ten children in my kindergarten, four are children of drug mothers. They seem to have no short-term memory; they seem to learn one day, and by the next day it's gone. They have trouble sitting still. We say one boy has springs in his feet.

—Gloria Kramer, Kindergarten Teacher
San Diego School District

TESSA

(Two Years Later)

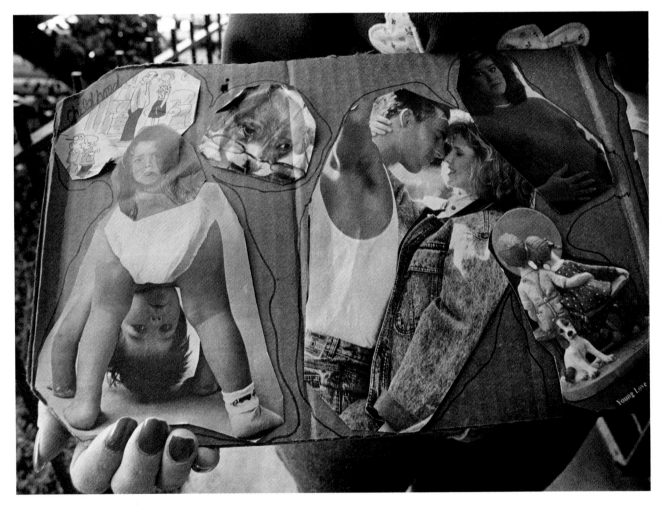

Tessa made a collage as part of her recovery program:
images cut from magazines that represented
important events and feelings she had while
growing up.

"My son can now go to school and say, 'You know, my mom is clean.'"

Life is just really good. It doesn't mean that I don't have bad days, it just means that life is so much better now that I don't use. There's no real excuse for me to go out and get loaded. I've been clean for over four years now, and I've found a lot of gifts to being clean: I feel good about myself, I have a straight head, I can be a good mom. I'm working with women in recovery, so I'm going to college for that, getting an associate degree in behavioral sciences. I'm also getting married next year.

Recovery for me is about having people in my life who care about me. I don't have to go each day thinking where am I going to get my next drug. Each day I wake up in the morning and I think I want to do something good for myself or for my kids.

I've been working really hard at being a better mom, going to parenting classes every chance that I can. I'm one of those parents who gets involved with my son and his school. That's something I've been working on this last year. I participate. I'm not the one who sits on the sidelines and lets the system just take advantage of me, run me over. I don't want to be one of those statistics of women who do nothing, and I don't want my children to be one of the lost generation.

Both my kids are drug-exposed babies. I really don't want to label them, and I don't want the system to label them. So I go and talk to the teacher. It feels really good to be a mom and to set an example for my kids. Now, when they're having the Say No to Drugs Program, my son can go to school and say, "You know, my mom is clean."

I'm getting married in January. He's in recovery, too. He has a little bit less time than me, but it's the first relationship I've ever been in that wasn't abusive. And we're really trying to work towards a healthy relationship. It's a nice change to be with somebody who's clean and who respects me and who cares about me and cares about my feelings. It's one of the many gifts I've gotten in this program.

The one thing I want to express is that there is hope in recovery for women. I want to educate people not to be so down on women, you know, using. Because it's not really about using drugs, it's about being sick from the disease of addiction.

I really didn't like being judged when I was out there. And I see so much of that going on. People seem to want to separate themselves and judge others who aren't doing what they think they should be doing, like not using drugs, or not being on welfare, or not living on the streets. It really saddens me when I see people being so judgmental and sitting on the sidelines, not really doing anything to help their community, yet they have so many opinions.

I never thought in a million years that I'd be in recovery and that, at the same time, I'd be able to help my fellow addicts. It's really a gift for me to be able to help other people today, because when I was out there using, people judged me so much that I didn't feel they cared about me, so I didn't care for them. I've learned that people care about me today. And I've learned that I have the ability to care for and love other people.

I know from my own experience that there is hope. People can change. I have.

—Tessa

V
Recovery

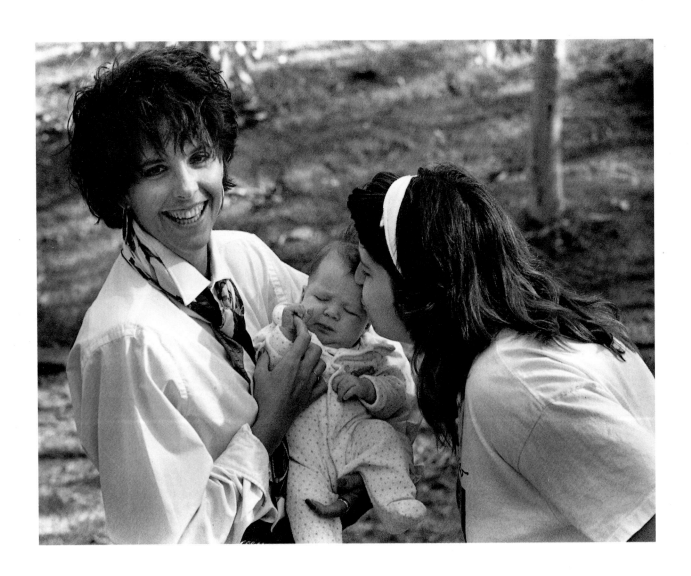

THE MIRACLE

This work is sad and difficult, but it's the miracles that make me strong, keep me doing my job. Like the miracle of seeing a woman walk through my office door, looking great, and I don't recognize her from the person she was on my couch three weeks earlier. It's amazing the change that can happen when a woman frees herself from drugs.

How does she free herself? Through recovery programs such as Kiva, Options, or any residential program that supports the part of her that's fighting to get stronger. By the time she comes into treatment, the chemical that she started using to make herself feel better is no longer making her feel good anymore. Her whole life is a mess, most of the time. She may be living on the street, she doesn't have anything or anybody.

When a woman is actually ready and willing to stop using, she will do whatever she has to do, including growing up all over again. Let me explain what I mean by that. Let's say I started using drugs when I was 14 years old and stopped using when I was 24. Emotionally, I would be like a 14-year-old. The drug is likely to stop an individual's whole developmental processes. Someone addicted to drugs stops developing emotionally at the point she started using.

A recovery program teaches her how to feel better about herself, without using chemicals. She learns how to be responsible. I know for myself, I feel good when I pay my bills, pick up around the house, buy groceries. A woman in recovery feels better about herself when she is being responsible and has structure in her life. She has support, she's around other women, she goes to a lot of 12-step meetings, she learns she has a choice. Every day she has to choose not to use.

And she learns the tools to remain drug-free by going to 12-step meetings, learning how other people, other addicts and alcoholics, live their lives. By using the 12 steps, she learns effective ways of coping and creating a good life for herself.

—Melanie Summers-Dain, Social Worker
Child Protective Services

Speakbody

Giving up the drug was hell, like ripping my skin off,
like turning myself inside out.
But there was this whole new person underneath.

—Marianna

If not for her skin, you might be able to see it, the itch.
It pulls her fingers to scratch the back of her knees,
the underhair of her neck. It draws them to her skin in a circle dance
that will not end. She is released when she lets blood.
Since the first night she stained sheets, they have tried to get word to her,
guided her nails to scrape long lines in her flesh. Even the air around her,
like sandpaper, leaves behind fine dry scales of herself.

Today she hurries home, two flights of stairs, spreads a white cloth
on the desk. She smoothes it, unwraps a small blade.
She pulls the zipper down the back of her blouse, lifts it over her hair.
She steps from her skirt, kicks off sandals. Somewhere, a cat.
She fingers the blade. *Pain that has floated me,* she says,
and the radio beside her wafts in and out of stations.
She runs a fig opening across the edge of her belly,
slips the blade along her breasts, between them
to her neck, across her shoulders, around her waist.

Mouths on her grow in rows, their tongues budding.
What took you so long, they say. She leans closer.
She cuts her thighs to the knees, steps from the topskin of her legs,
down both arms to the elbows, her back sliding off in one piece.
She hangs the skins like blouses to dry.
She runs the blade sideways to her hips, pulls—

Moons that have entered her body each month now rise.

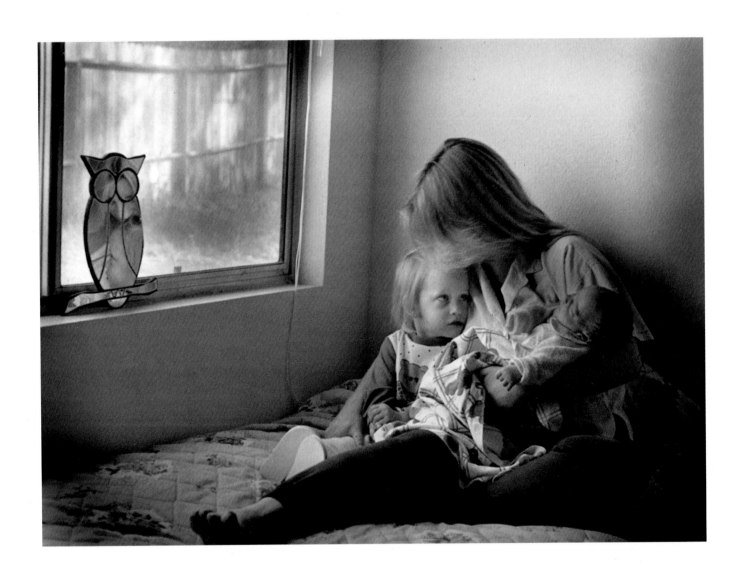

"I have a choice."

All the pain and the fear was covered up when I was doing drugs. I really don't remember a lot of it, because I was so totally out there. I'm lucky that my daughter lived through it, and that I lived through it.

Whenever I got high, I'd get so schizo, I'd have two personalities: one was wanting to get high—I couldn't stop myself from wanting to get high—and the other one knew that if I got high, I would be insane. And I knew what the outcome would be. It would be me and Tom fighting, and me running around the house driving myself crazy, tweaking.

The personality that wanted to get high always won. There was no competition. That one was always stronger.

It's real scary. That's why I'm in this recovery house for support. Thank God for these houses, and my roommate, and these counselors, and having someone beside you who knows what you're going through, and can relate to what you're doing. I never would have made it alone.

Through this Kiva program, I've learned that I have a choice. Now the personality that doesn't want to use drugs is stronger. It's great.

—Susan

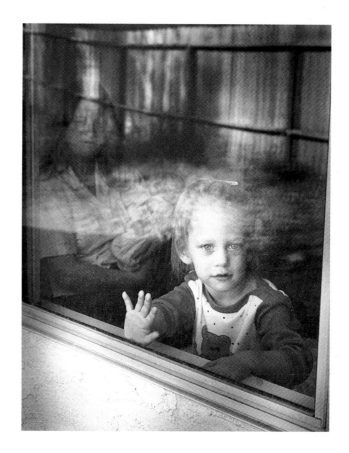

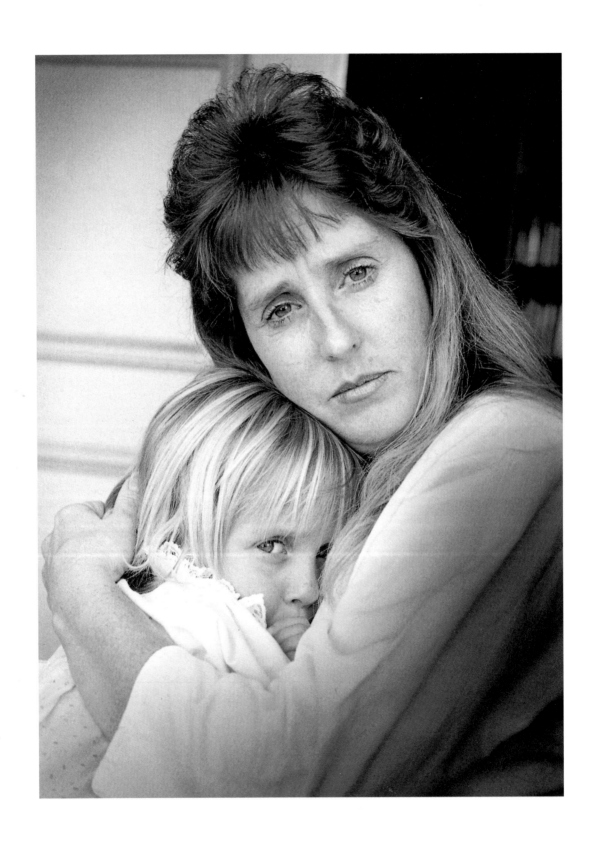

"I would do my lines and go on with the laundry..."

I've been clean a year now, but for the last, what, seven years, crystal was my drug. It started out a social thing, you know, to fit in. Toward the end, I was doing crystal by myself. It wasn't about being with friends, it was something I needed to get. If I didn't have crystal, I didn't feel normal.

I got married and started a family. My husband and I did the everyday things, but we were always high doing it. It wasn't like a party thing, it was an everyday thing that I had to do in order to get through the day. I would get up in the morning, take the kids to school, do my lines and then go on with the laundry and the cleaning and the cooking. If I wasn't high, I was sleeping.

My sister used to tell me that I needed to stop doing it. And I used to tell her that I couldn't really stop. I didn't know that there was another way to live without doing drugs. I didn't want to live that way any more, and yet, I couldn't find a way out. I can remember I wanted to quit so bad, I would even send away for drug books. I'd read these books, but I'd be high when I was reading them.

When you're a drug addict, you have to want help. You have to be willing. And I became willing. I knew that I had to get help. You have to get to that point. You know, people go into these programs, the court tells them to, they have to, and usually they back out, using.

I can remember that feeling of hurting, of pain, of help-lessness. Of not knowing what to do. And I knew Kiva [recovery program] was a way, that it was hope. I had a lot of unmanageability in my life, my house was a mess, my life was desperate. That's what it was.

I asked my parents if they would take the kids. They wouldn't take the baby Danielle, but they took the other two kids. I called my Child Protective Services worker and they, I, put Danielle in a foster home. And I went into Kiva, and I stayed there for seven months. It was real hard because I didn't have my kids with me, I didn't have Danielle with me, and she was just a baby. She was only five months old.

About a week after I went into Kiva, Danielle had to be taken from the foster home and put into the hospital because of her failure to thrive. She didn't want to eat. She was in the hospital, and I was at Kiva, and I couldn't leave to go see her.

I missed being with her, and a lot of that was guilt for not taking care of her right. Because I used drugs the whole time I was pregnant with her. The whole time. And it took me a real long time to be able to even say the words, "Yeah, I used drugs almost every day I was pregnant." That's one of the things that I worked on when I was at Kiva, talking about the guilt. And being able to let that guilt go, because if you hold on to that, then the pain will take you back out using again.

For the first five or six months that I was at Kiva, I didn't have Danielle with me. I couldn't have her until they thought I was ready. Not until I moved to Kiva II. Then when I saw my baby and I was clean, it was like, God, I couldn't believe it. Because I just didn't realize that I wasn't taking care of her. I didn't know how sick she was until I got clean, and I could see it just by looking at her.

It wasn't like I'd been saying, "Screw my kids!" It wasn't like that. It was the disease, the drug addiction. I was sick. I think that's what people really need to realize. It's not that I was a bad mother. It was the disease. I was in my own disease.

—Denise

Surfacing

When I saw my baby and I was clean
it was like, God, I couldn't believe it.
I just didn't realize that I wasn't taking care of her.
I didn't know how sick she was until I got clean
and I could see it just by looking at her

— Denise

How can you not know what you know,
I ask the woman who is using my voice,
wearing my red shirt, doing a line.
I am floating somewhere inside
of all this, as if this time I am the baby
inside the woman's belly, white powder
is mounting, icebergs displacing water

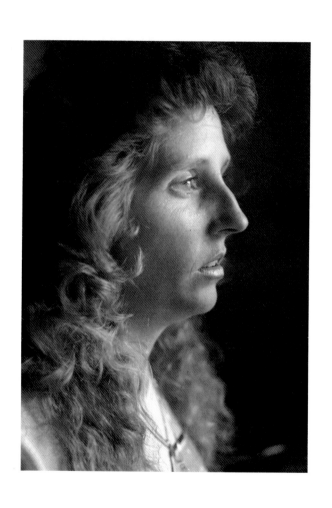

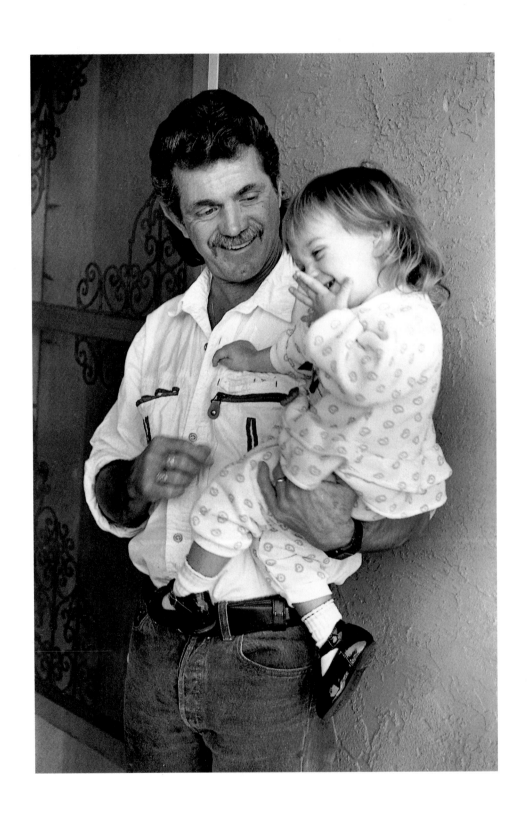

Norm had been clean for seven months when he met Denise. They went together for several months before they married. Together, they are raising a family of four children, including their new baby, Sara.

I grew up in the projects in Los Angeles. We were forty guys in the gang. Kids from the neighborhood, from Harbor Hills, San Pedro, and kids from Palos Verdes too, rich kids who joined our club. All but three of us are dead. Maybe it's my Choctaw and Apache heritage that's taught me to survive.

The others died tragic deaths—killed in gang fights, drug overdoses, a few of them got shot by the cops in a robbery. The two other survivors, brothers, went into the Navy. One now has a construction company, the other owns a school for paraplegics.

To survive in the projects, you've got to join a gang. I was 12 when I had to fight three members to get in. You have to go along with whatever's going down—like stealing, fights with rival gang members. I got to be the vice president and the warlord.

We were like a family. It was the only life I knew. I didn't know anything about clean and sober. My mother drank. I had five stepfathers. She was a barmaid, worked nights. She was a good mom, she tried, but I had to do it my way. When I hit 15, I was at the age where no one was going to tell me what to do. I was my own man. I was using, shooting dope.

It was at that time I heard about Teen Post. A program to get members off the street. I became a boxer, lightweight. Then I traveled to New York to run from my addiction, but the addiction would go along. The addiction was me. It was on the inside. I had to have dope every day. I was a loner, used by myself a lot. When I'd shoot dope, I'd shoot to take myself out, I didn't care about dying. My heart stopped a couple of times, but that didn't scare me. Like I said, I didn't care about dying.

Five years ago, I got busted and they told me to go to AA. Oh, I'd go, but then I'd go to the bathroom and slam dope. I did their little AA thing. But it wasn't about getting clean and sober. I'd go into detox and tell the counselors what they wanted to hear.

Then I went back out and used again. And again, I got busted and went to jail. I'd been in jail before, but this was the first time that I was uncomfortable there. The AA seed had been planted. I prayed to God to let me out. My cousin bailed me out. I remember she said, "I love you so much. I hope you're done using dope."

I called Jean McAlister at the McAlister Institute. I wanted to get into a recovery program. I had thirty days sober. She didn't let me come in for a month. She wanted to see how serious I was. I tested three times a week for a month, and all my tests came up clean. Then she let me in. She saw the willingness there. I was in for fourteen months.

When I got seven or eight months clean, I met Denise, and we fell in love. I went with her for about three months, and we began to plan a wedding. We did it the right way, paid for it ourselves. We were responsible. We went to a jewelry shop, started paying on a ring. I paid off on a tuxedo for me and my stepson. We started saving for a honeymoon, and paid it all off. I was proud of myself. We went to Vegas for four days. We were supposed to be on the fourth floor, but they put us in a suite at the top. It brought tears to our eyes.

The disease of addiction was rabid in Vegas, but it didn't affect us. We have our recovery, and we have each other. Today, I'm working at the McAlister Institute as a drug counselor for detox. And we go on a honeymoon every year.

My mom? She's still alive. She's going to be 80. We had a surprise party for her last month. My little girl is her whole life. And, my mom has me. I've been shot at, she's seen me stabbed many times. She's real happy I'm still living. We were in the car the other day, I was taking her to the grocery store, and she turned to me and said, "You know, son, I'm proud of you. I'm so glad you're alive."

—Norm

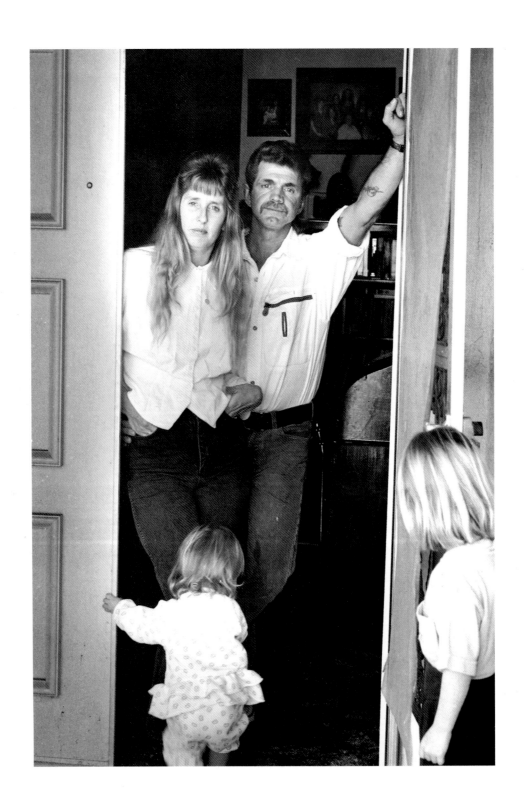

"This has been the learning year."

On December 13th, I'll have four years clean. I'm working for McAlister Institute in a recovery program called Options, for pregnant women, and I'm married to Norm, and we have a new baby, Sara. She'll be a year and a half, and she's my first clean baby. It was totally different this time. When I was pregnant with my other three kids, I didn't really notice anything. It just seemed like one day I was pregnant, and the next day I was having it, and the next day they were grown.

But when I was pregnant with Sara, I noticed everything about the pregnancy: I found out real early, because I cared to find out early. I missed a period, I went to the doctor. I remember I felt her move. And when she was born, we videotaped it. It was a real occasion. I remember the first time Sara played with the toys on her swing, I got so excited. I noticed all those things about her, which I didn't with any of the other kids.

Something else that's totally different is my friends. Today, I have people that I can rely on at any time. Like the other day when we had a surprise party for Mom, our friends came over and they fixed up the house while we went to pick her up. I can just depend on my friends today.

Before, when I was using, when I had the dope, there were friends around. When I didn't, they weren't around. And you could never depend on them for anything, except maybe to rip you off. You could depend on that. And I did the same thing, I was the same type of friend. I would get the dope and I would cut it and sell it to my friends. I didn't know how to be a friend either.

In this year of my recovery, my fourth year, I've been getting in touch with my feelings, and who I am as a woman, and that I am a woman. I go to a women's group, not affiliated with NA [Narcotics Anonymous], twice a month. It's real intimate. It's five women, and we start it off by burning sage and cleansing our bodies. Everything we say there is confidential, and we talk about our deepest feelings. I go in there thinking everything is OK, and I come up with things I had no idea were going on with me. Real deep deep stuff.

It's all new to me, trust, I mean. I never trusted women. I never trusted men. I never trusted anyone. I think a lot of it is the way I grew up. My parents didn't beat me and they weren't addicts. But they were real dysfunctional. I can't even remember once when my parents told me that they loved me. I can't remember them holding me or hugging me. They never learned themselves.

So I didn't learn how to express my emotions. Even today, I remember sitting in that women's group and saying, "I'm feeling sad," but I didn't know why. I just felt unemotional. I still don't know how to express myself. Even though I've had four years, this has been the learning year.

—Denise

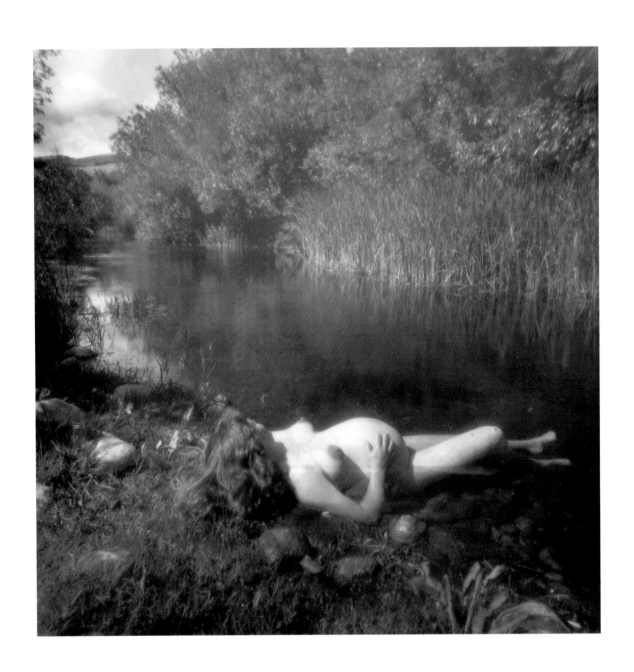

Natural High

I come in from the wind

I come in from the sea
sand in my teeth
night wet
in the small of my back

I come onto the land
and roll in the sand and
life's mouth
is brushing my thighs

and it's worth it, it's worth it again and
the moon yes the moon
tells it over and over
and what's more I love it
once more I love it
my life is alight
at last

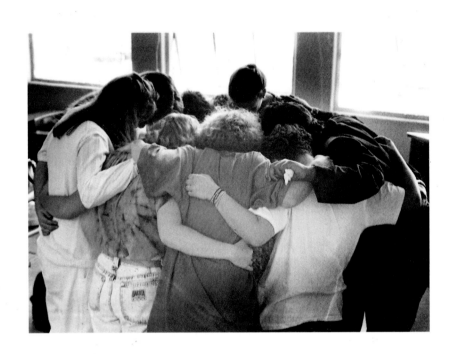

Re-Membering

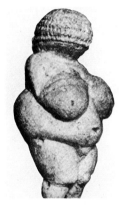

Venus of Willendorf,
ca. 25,000 B.C.E.

In the oldest artifacts yet excavated, we discover the female as primary power.
She is at the very center of what is sacred and necessary.

—Christine Downing, Professor and Author
 Former President, American Academy of Religion

I've heard whispers of old ways, of not needing to need a fix—
a snort, a toke, some booze, a man. I've heard about the Goddess,
searched books on bookshelves for pictures of old ways.
I've heard it believed woman's power surged like a current inside her.
She could turn seeds into bread, her blood into milk, her body into babies.
I've heard she was sacred. I've heard seeds she pushed into earth
that grew tall into grain, she named farming. On cave walls she carved
we are all sisters here and named it writing. Lately, I've heard
the *cloc cloc* of her return, her eyes a deathpit of what she has seen.
no more, she says, her arms extending the sea, *this
is the surge of what we will be*

The Opening

I no longer hold back
hold back
a part of me, hold back
the great dark bird
sleek and shuddering
beneath my skin—
I'm opening
opening to exquisite flight

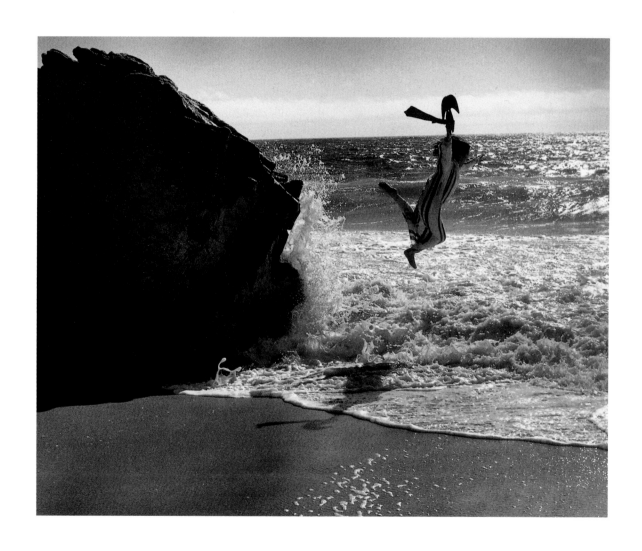

If you are interested in getting involved in this issue or are seeking help,
the following resources are listed to help you take the next step.

Hot Lines

Alcoholics Anonymous and Narcotics Anonymous
Local chapters are listed in the White Pages.

Alcohol information and referral line
800-ALCOHOL (800-252-6465)

National Council on Alcoholism and Drug
Dependence Hope Line
800-NCA-CALL (800-622-2255)

Help for cocaine addiction
800-COCAINE (800-262-2463)

Center for Substance Abuse Treatment
800-662-HELP (800-662-4357)

National Organization of Fetal Alcohol Syndrome
800-66-NOFAS (800-666-6327)

Questions or medical assistance for AIDS
800-342-AIDS (800-342-2437)

Treatment and Information Sources

Alcoholics Anonymous and Drug Abuse Information
Centers are listed in the White Pages of local
telephone directories.

American Civil Liberties Union
Women's Rights Project
132 W. 43rd St., New York, NY 10036
212-944-9800, ext. 521
(For protecting the rights of pregnant addicts.)

Clearinghouse on Child Abuse and Neglect
and Family Violence Information
P.O. Box 1182, Washington, DC 20013
703-385-7565

The Coalition on Alcohol and Drug Dependent
Women and Their Children
1511 K St. NW, Suite 926, Washington, DC 20005
202-737-8122

March of Dimes Birth Defects Foundation
1275 Mamaroneck Ave., White Plains, NY 10805
914-428-7100
Local March of Dimes chapters are listed in the White Pages.

National Association of Healthy Mothers/Healthy Babies
409 12th St. SW, Suite 309, Washington, DC 20024
800-673-8444 or 202-863-2458

National Association for Perinatal Addiction
Research and Education
200 N. Michigan, Chicago, IL 60601
312-541-1272

National Association of State Alcohol
and Drug Abuse Directors
444 N. Capitol St., NW, Suite 642, Washington, DC 20001
202-783-6868

National Council on Alcohol and Drug Dependence
1511 K St., NW, Suite 926, Washington, DC 20005
202-737-8122

National Commission to Prevent Infant Mortality
330 C St. SW, Room 2014, Washington, D.C. 20201
202-472-1364

Center for Substance Abuse Prevention
5600 Fishers Lane, Rockwall 2 Bldg., Rockville, MD 20857
301-443-0365

Tough Love International
P.O. Box 1069, Doylestown, PA 18901
215-348-7090

The Women's Program of CASPAR
(Cambridge and Sommerville Program for Alcohol and
Drug Abuse Rehabilitation)
6 Camelia Ave., Cambridge, MA 02139
617-661-1316

Reading Materials

Abel, Ernest L. *Fetal Alcohol Syndrome.* Oradell, New Jersey: Medical Economic Books, 1990.

Baar, Anneloss van. *The Development of Infants of Drug-Dependent Mothers.* Amsterdam: Swets and Zeitlinger, 1991.

Barth, Richard P., Jenne Piatrzak, Malia Ramler. *Families Living with Drugs and HIV: Intervention and Treatment Strategies.* New York: Guilford Press, 1993.

Brackbill, Yvonne, Karen McManus, Lynn Woodward. *Medication in Maternity: Infant Exposure and Maternal Information.* Ann Arbor: University of Michigan Press, 1985.

Dorris, Michael. *The Broken Cord.* New York: Harper and Row, 1989.

Finkelstein, N., S. Duncan, L. Derman, J. Smeltz. *Getting Sober, Getting Well: A Treatment Guide for Caregivers Who Work with Women.* Cambridge: The Women's Program of CASPAR, 1990.

Finnegan, L.P. "**Prenatal Substance Abuse: Comments and Perspectives,**" Seminars in Perinatology. 1991.

Finnegan, L.P., T.A. Hagan, K.A. Kaltenbach. "**Opiate Use in Pregnant Women,**" *Bulletin of New York Academy of Medicine.* 67 (3), p. 223-239, 1991.

Jessup, Marty. *Drug Dependency in Pregnancy: Managing Withdrawal.* Maternal and Child Health Branch, California Department of Health Services, 1992.

Lusane, Clarence. *Pipe Dream Blues.* Boston: South End Press, 1991.

Mayes, Linda. "**Prenatal Cocaine Use: A Rush to Judgement,**" *Journal of the American Medical Association.* January 1992.

Roth, Paula. "**Recent Research: Alcohol and Women's Bodies.**" *Alcohol and Drugs Are Women's Issues,* Vol.1. Scarecrow Press, 1991.

State Inter-Agency Task Force on Perinatal Substance Abuse. *Option for Recovery: A Report on Services for Alcohol and Drug Abusing Pregnant* and *Parenting Women and Their Infants.* Sacramento, Calif.: The Task Force, 1992.

Zuckerman, Barry. "**Crack Babies: Not Broken,**" *Journal of Pediatrics,* January 1991.

Walker, Lenore. "**Abused Mothers, Infants, and Substance Abuse: Psychological Consequences of Failure to Protect,**" *Proceedings of the American Psychological Association.* January 1991. Washington, D.C.: Georgetown University Child Development Center, 1992.

Videos

Women of Substance, produced by Video/Action Fund in partnership with Infant Mortality Commission, Legal Action Center. Video/Action Fund, 3034 Q St. NW, Washington, DC 20007. 202-338-1094. (This video is of interest to laypeople and health-care providers.)

Straight from the Heart: Stories of Mothers Recovering from Addiction, produced by VIDA Health Communications, 6 Bigelow St., Cambridge, MA 02139. 617-864-4334. (This video is of interest to laypeople and health-care providers.)

A Challenge to Care: Strategies to Help Chemically Dependent Women and Infants, VIDA Health Communications. (This video is geared toward health-care and social-service providers.)

Special thanks to the following for their help in compiling this resource list: Loretta P. Finnegan, M.D., National Institute on Drug Abuse; Susan Weiner, M.S.N., March of Dimes Birth Defects Foundation; Martha McPhail, M.L.S, San Diego State University; and Rory Kennedy, Video/Action Fund.

Other Titles Available from NewSage Press

Blue Moon over Thurman Street
by Ursula K. Le Guin
Photographs by Roger Dorband

The C Word: Teenagers and Their Families Living with Cancer
by Elena Dorfman

Stories of Adoption: Loss and Reunion
by Eric Blau
Foreword by Annette Baran

Organizing for Our Lives: New Voices from Rural Communities
by Richard Steven Street and Samuel Orozco
Foreword by Cesar Chavez

Exposures: Women & Their Art
by Betty Ann Brown & Arlene Raven
Photographs by Kenna Love
Foreword by Alessandra Comini

A Portrait of American Mothers & Daughters
by Raisa Fastman

Women & Work, Photographs and Personal Writings
by Maureen R. Michelson and Michael Dressler

Common Heroes: Facing a Life Threatening Illness
by Eric Blau

The New Americans: Immigrant Life in Southern California
by Ulli Steltzer
Foreword by Peter Marin

Exhibition Information:
A traveling exhibition based on the book *When the Bough Breaks: Pregnancy and the Legacy of Addiction* will be sponsored by the March of Dimes through 1994. Contact NewSage Press for dates and locations.

NEWSAGE
PRESS

For a complete catalog, write to:
NewSage Press
825 N.E. 20th Ave., Suite 150
Portland, OR 97232
(503) 232-6794